SURFACE DESIGN

PAINTING,
STAMPING,
STENCILING, AND
EMBOSSING FABRIC
& MORE

SANDY SCRIVANO

The Taunton Press
Inspiration for hands-on living™

The Taunton Press, Inc., 63 South Main Street, PO Box 5506, Newtown, CT 06470-5506
e-mail: tp@taunton.com

Distributed by Publishers Group West

DESIGN AND LAYOUT: Lori Wendin
ILLUSTRATOR: Rosalie Vaccaro
PHOTOGRAPHERS: Jack Deutsch, Ken Gutmaker
COVER DESIGNER: Rosalind Loeb Wanke
COVER PHOTOGRAPHER: Jack Deutsch

LIBRARY OF CONGRESS CATALOGING-IN-PUBLICATION DATA
Scrivano, Sandy.
 Creative surface design : painting, stamping, stenciling, and
embossing fabric & more / Sandy Scrivano.
 p. cm.
 ISBN 1-56158-486-X
 1. Acrylic painting--Technique. 2. Textile painting. 3. Furniture
painting. 4. Stencil work. 5. Decoration and ornament. I. Title.

 TT385 .S38 2002
 746.6--dc21

 2002003443

Printed in the United States of America
10 9 8 7 6 5 4 3 2 1

IN MEMORY OF MY FELLOW ARTIST AND FRIEND, NANCY CORNELIUS

acknowledgments

I T MAY TAKE A VILLAGE TO RAISE A CHILD, but it takes a whole lot more than that to write a book. My thanks, gratitude, and admiration go to a host of people, including my family, who remained nice to me even when I didn't deserve it. Ed Detwiller is a whiz as a furniture maker and carpenter, and it shows in several of the furniture projects. Colleen Tonkin is a wonderful patternmaker, fitter, and cutter—and on top of that, she is my hand model. Nadia Nedashkovskiy is a flawless seamstress who works like the wind. Yvonne Ringle did the beautiful beadwork on the evening wrap I designed. Sherry Lacabanne did a fabulous job on the home dec sewing front, with goodwill and speed. Dana Bontrager and Diane Ericson are friends, artists, and businesswomen, who supply my creative fire. Marcy Tilton is also a friend and artist who inspires me.

The following companies have been very generous with information and products: Nova Color, Jacquard Products, Hot Potatoes, Things Japanese, ReVisions, and Purrfection Artistic Wearables.

The unsung heroes are the people who actually produced the book. My kudos to the creative folks at The Taunton Press; my editor, Dorcas Comstock; and photographers, Ken Gutmaker and Jack Deutsch. Your skill and genius is incredible. *To all of you, thanks!*

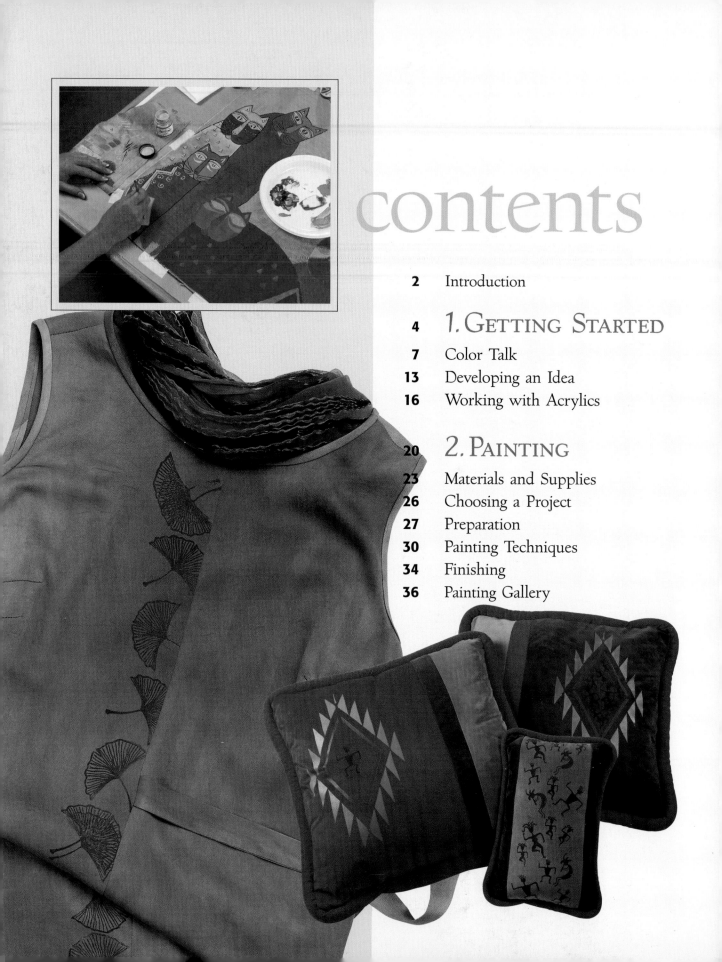

contents

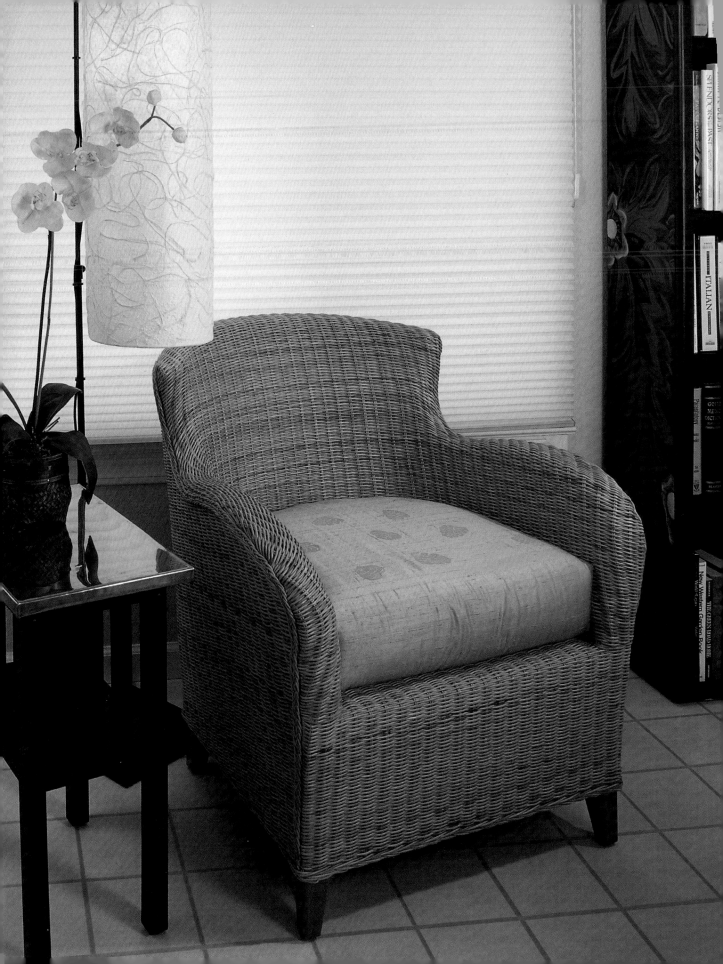

introduction

IT HAS BEEN SAID THAT TECHNOLOGY gives us the way to live, but art gives us the reason for living. Art, in all its forms, enriches us: It challenges us, it amuses us, it creates interest, and best of all, it gives us pleasure. Art just makes us happy. It is my theory that we embellish the things in our lives to give ourselves pleasure. What better reason could there be?

In this book, I'll be showing you some ways to embellish your clothing and your home. The techniques covered include painting, stenciling, stamping, and embossing. Decidedly, the examples selected reflect my personal style and design ethic, but the techniques described are universal and can be applied with your preferences in mind.

For an artist, some of the greatest pleasures and successes come from asking,

"What if...?" Before writing this book, I had never considered making a leather-covered table. Now, I'll never be without one—or more! Painted furniture is another potential canvas. Hmmm. How about trying...on my bookcase? What if...? Fabrics, of course, are a natural choice for embellishment. The techniques described in this book can be applied to the filmiest silks and heaviest split cowhide with equal success.

Nurture your own creativity. Start asking yourself, "What if...?" Try new materials and experiment with different mediums. The end result may take on different forms, but the root ideas will remain the same.

Feel free to adapt the projects you see here to please yourself. Experiment, have fun, and enjoy the results.

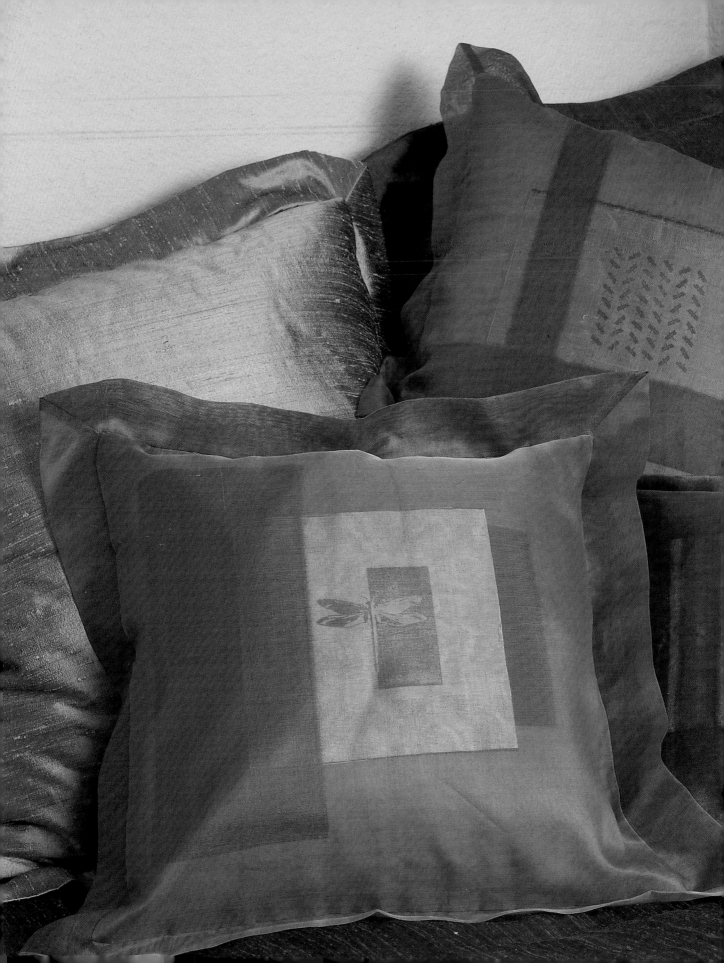

1

getting
started

getting started

WHEN EMBARKING ON A NEW JOURNEY, it's helpful to have some road maps. The sections in this chapter are just that—guides to help you along the way. Beginning with the section on color, you'll learn a bit about color theory and why color works the way it does, as well as about particular color combinations and relationships. Having an understanding of color will make you a stronger artist. But don't worry, there's enough information to help you succeed, but not so much you'll feel overwhelmed.

When you get an idea for a project, it's sometimes difficult to translate that idea into a finished project. The section on developing an idea outlines some simple, concrete steps to focus and channel your creativity and to make your idea happen.

Finally, you'll learn about my medium of choice—acrylic paint. Acrylic paint is versatile, readily available, and comes in a huge variety of colors and finishes—there's certainly something for everyone. With all this in mind, let's get started!

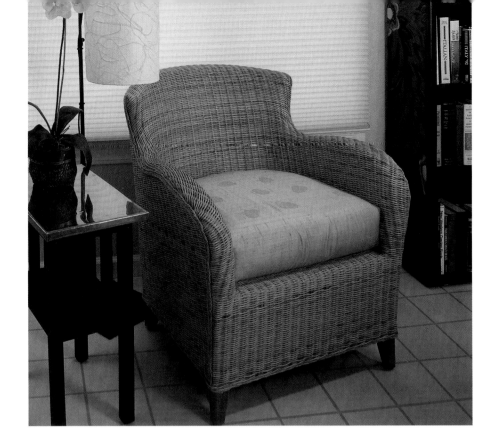

The subtle tone-on-tone stamped fabric on the chair cushion provides a contrast to the vibrant colors of the painted book-case without competing or overwhelming. Wicker, silk fabric, and copper add textural interest.

Color Talk

While exploring the San Francisco Museum of Modern Art, I was struck by this 1914 quote by artist Paul Klee: "Color possesses me. I don't have to pursue it. It will possess me always, I know it. That is the meaning of this happy hour. Color and I are one. I am a painter." Although color may not evoke the same degree of passion in each of us, we can hardly deny its impact. Every aspect of our lives is influenced by color. Color is descriptive and evocative. It can remind us of other times, other places, other things. It can be powerful, or it can be subtle. It can stimulate us, or it can soothe us. It can create and modulate mood.

Basic color concepts

Before an artist or a craftsperson can fully engage the power and subtlety of color, he or she must first have some understanding of color theory. You probably already have an intuitive sense of "what works," but it may surprise you to learn that there are principles that explain why various color combinations do work. Having a better understanding of how color works will vastly increase your creative skills. Without going into scientific detail, let's explore some basic concepts and develop a 12-color wheel.

THE COLOR WHEEL In 1770 Moses Harris defined red, yellow, and blue as the three

12-Color Wheel

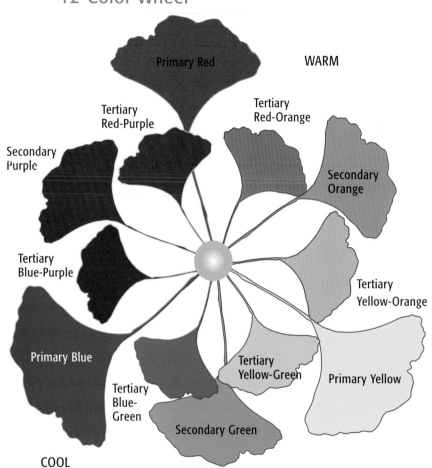

WARM

Primary Red

Tertiary Red-Purple

Tertiary Red-Orange

Secondary Purple

Secondary Orange

Tertiary Blue-Purple

Tertiary Yellow-Orange

Primary Blue

Tertiary Yellow-Green

Primary Yellow

Tertiary Blue-Green

Secondary Green

COOL

primary colors; that is, those colors that cannot be created by mixing other colors. He placed these colors an equal distance apart in a circular pattern to create a color wheel.

In the 1800s Johann Itten added secondary and tertiary colors to the color wheel. The *secondary colors*—orange, purple, and green—are created by mixing two primary colors: red and yellow make orange, blue and red make purple, and blue and yellow make green. The secondary colors are added to the color wheel between their corresponding primary colors.

This leaves six spaces blank in a 12-color wheel. These spaces are filled with the *tertiary colors,* which are created by mixing together a primary color and a neighboring secondary color. Thus we have yellow-orange, red-orange, red-purple, blue-purple, blue-green, and yellow-green.

When correctly positioned, the primary, secondary, and tertiary colors create what is known as *the natural spectrum.*

HUE, SATURATION, VALUE Let's continue now to *hue,* which is the same thing as color. Hue is any color except black and white.

Saturation, or chroma, indicates the intensity of a color. For example, red has a higher saturation than pink, which is red mixed with white, or than maroon, which is red mixed with black. Highly saturated colors are pure, vivid, and rich. Colors with little noticeable white or black added are called *bright.*

Hue, Saturation, Value

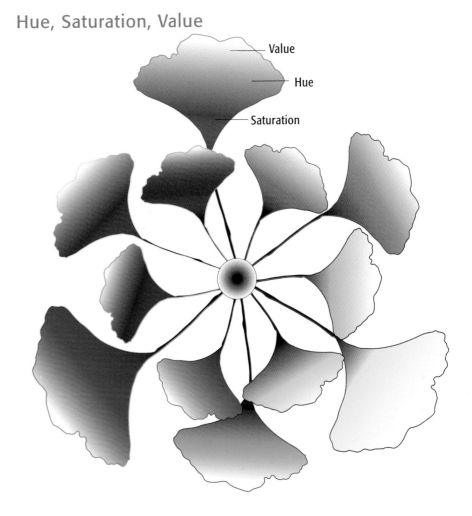

- Value
- Hue
- Saturation

Value is the lightness or darkness of a color. Value is created by adding white to a color, which results in a *tint*, such as pink. *Pale* colors are tints containing large amounts of white. *Light* colors are mostly white with only small amounts of hue added. Adding black to a color produces a *shade,* such as maroon. Medium value colors, or *tones,* have various proportions of both black and white. These are always more subdued than the original color. Now you know what "toned down" really means.

HOT AND COLD COLORS *Hot* and *warm* colors are based in red. Hot colors are attention grabbing and stimulating. The addition of various amounts of yellow softens hot colors to a warm range; warm colors feel inviting and comforting.

Cold and *cool* colors are based in blue and green. Cold colors can feel frigid and austere, but cool colors that contain blends of yellow and red are viewed as tranquil and soothing.

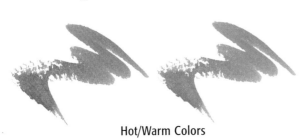

Hot/Warm Colors

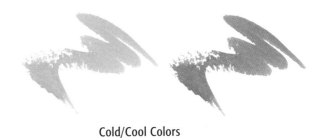

Cold/Cool Colors

Warm colors register on the human eye before cool colors do, which is why warm colors seem to advance, and cool colors seem to recede. Usually, one of the color temperature ranges will feel more comfortable to you because of your personal coloring.

Basic color schemes

To see how colors work together and gain impact, let's take a look at some color schemes, beginning with the most basic, a primary color scheme.

PRIMARY A *primary* color scheme combines pure red, yellow, or blue. The combination is clear and forceful, as exemplified in paintings by Piet Mondrian.

Primary Color Scheme

SECONDARY A *secondary* color scheme uses the secondary hues of orange, green, and purple. A combination using these colors feels fresh, and the colors can be modulated into subtle tints and shades.

Secondary Color Scheme

TERTIARY TRIAD Just to make things more interesting, there are two *tertiary triad* combinations, which are composed of three colors equal distances apart on the color wheel. These combinations are red-purple, yellow-orange, and blue-green; and red-orange, yellow-green, and blue-purple (see the 12-Color Wheel on p. 8).

COMPLEMENTARY A *complementary* color scheme uses two colors that are directly opposite each other on the color wheel; for example,

Complementary Color

ANALOGOUS An *analogous* color scheme is made up of any three hues—or the tints and shades of those hues—that are next to each other on the color wheel. This type of color scheme is pleasing to the eye.

green and red. This opposition creates a visual balance and, at the same time, makes each of the individual colors appear more vivid.

Analogous Color Scheme

SPLIT COMPLEMENTARY Even more pleasing to the eye than a complementary scheme is the *split complementary*. Simply put, this is a trio containing one color and the two colors on either side of the first color's complement; for example, yellow, blue-purple, and red-purple.

MONOCHROMATIC A *monochromatic* color scheme is a peaceful one. It consists of any single hue in combination with any of its shades or tints.

Monochromatic Color Scheme

Split Complementary Color Scheme

Color Tidbits

The more you learn about the power and subtlety of color, the more easily you'll be able to achieve successful results. Here are a few interesting facts:

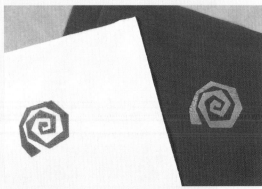

▲ Only about 80% of the visual signals from the eye go to the brain; the other 20% go to the pituitary gland. When we see the color red, epinephrine is released from the pituitary, causing a host of physiological responses such as increased heart rate. No wonder red "gets" to us.

▲ If a tone and a shade of the same color are next to each other, the tone appears lighter and the shade appears darker. For example, placing a maroon stamp on a pink background will make the color of the stamp seem more intense (top photo).

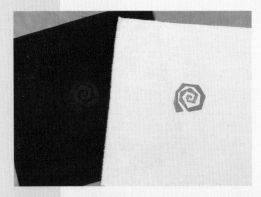

▲ You can create movement, or dimension, on a flat surface by grading a color from light to dark or from dark to light—or both.

▲ When a color is placed against a darker color, it seems lighter; when the same color is placed against a lighter color, it appears darker (center photo).

▲ Limiting a color to a particular feature of a project gives that color more significance. Likewise, using a single image on a project has more impact than using the same image in an allover print, as shown in the photo of the Hot Salsa Skirt on p. 81.

▲ If something is usually seen in a particular color range (for example, green leaves), a change in its color draws the eye and can be confusing. However, that change can also be used purposefully for effect: Blue leaves might look odd in a landscape, but they certainly make a striking graphic (bottom photo).

NEUTRAL A *neutral* color scheme is soft because it consists of colors that have been neutralized by the addition of their respective complements. *Tinting, toning,* and *shading* further expand the neutral color palette.

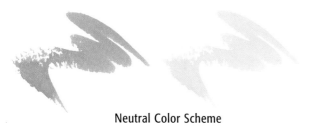

Neutral Color Scheme

ACHROMATIC Finally, there is the *achromatic,* or "without color," scheme, which consists of black, white, and all the grays that can be created through tinting and shading of hues. Adding small amounts of red, yellow, or blue varies the perceived color temperature and makes the gray feel warm or cool.

Knowledge of color schemes can help you create visual harmony. When you're not sure

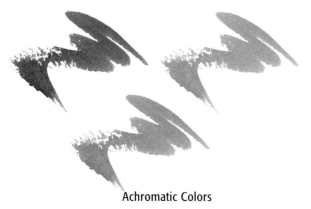

Achromatic Colors

about your color choices, if you want to punch up a combination, or if something just seems a little "off," don't become overwhelmed. Just take another look through this section to get yourself back on track.

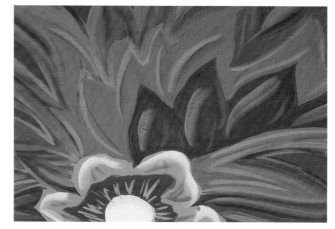

DEVELOPING AN IDEA

Sometimes creativity is inspired by images you just happen upon, such as the photo of a rug I noticed while flipping through the pages of a home furnishings catalog. The moment I saw that photo, I knew exactly how I wanted to decorate my entire sunroom. From the photo, I created the motif shown above; turn to p. 36 to see the way I used it in the sunroom. Spend some time thumbing through your favorite magazines and catalogs; you're sure to find inspiration for a single item or a whole room.

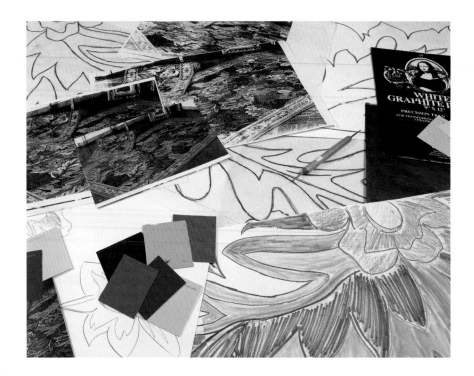

Select the color palette for the image you'd like to paint, then transfer the sketched image to the prepared surface of your project.

From impulse to execution

Moving from an idea to a completed project can be overwhelming, so let's demystify and simplify the process using a real-life example. We'll take a look at how I transformed a plain, natural finish oak bookcase into the central theme of my sunroom, beginning with the rug photo I fell in love with. Here are six easy steps to lead you through the process. The photo above shows the various materials I worked with; refer to this photo as you read the following.

1. Begin by enlarging the image to see the detail. In my case, I enlarged the catalog photo of the rug. If your image is in color, then make a color copy. Also make a black-and-white copy to see the color value; that is, how lights and darks register against each other. You can see my copies in the upper left portion of the photo. Value can be seen clearly in black and white, and this information is helpful when proceeding with the next step.

2. Select your color palette, keeping in mind color value. Then estimate the amount of paint you'll need, using the coverage amounts indicated on the paint labels as a guide. Transfer some of each color paint to squeeze bottles so that you won't have to stop and open a can every time more paint is needed.

3. Prep the surface of the item you'll be painting, as described in chapter 2, pp. 27–29. At this

point, I prepped the wood and applied a base coat to the bookcase. Note the underside of the shelves below, which I painted a lighter color to reflect more light.

3

4. Cut a piece of paper to the size of the design. There are two ways to get the image onto the paper: You can freehand sketch the image to fill the space as desired. Or, if you need more guidance, draw the image using a grid. First, pencil in a grid on your photocopy, then draw an enlarged grid on the paper that has been cut to size. Look at each box of the small grid separately, then sketch the design lines into the corresponding box of the large grid. When you are done—presto! a completed picture. With either method, you will have the design outline. To check your drawing before you begin painting, fill in the design with

colored pens or pencils. You can see how I did this in the lower right portion of the photo on the facing page.

5. Trace this sketched image onto tracing paper that has been cut to size. Transfer the image to the prepared surface using graphite paper, which comes in both light (for use on dark backgrounds) and dark (for use on light backgrounds) shades (see the upper right portion of the photo on the facing page). Place a sheet of graphite paper between the tracing paper and the prepared surface, then trace the design lines with a stylus or a mechanical pencil without lead.

Artist's Insight Often you can create additional interest by reversing a design or motif, or using only a portion of it. To reverse a motif, just turn your tracing paper over before you transfer the design to the prepared surface.

6. Apply paint to your transferred design, using the original image and colored drawing as guides. Let the paint dry thoroughly. After the paint is dry, if your project is wood, seal it with two coats of varnish to protect the finish, as I did to protect my bookcase.

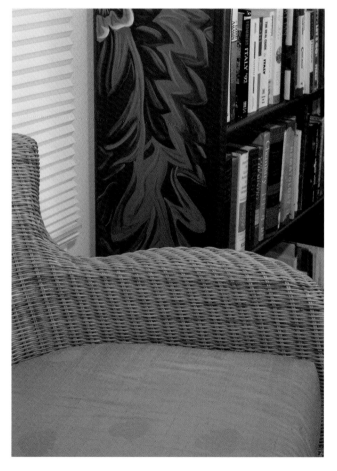

From so-so to sensational

Don't be afraid to take a creative leap after being struck by inspiration. Rather, build on that initial idea (as I did), using it as a springboard to decorate an entire room.

In need of more shelf space? Paint a 10-foot-long bookshelf with the same pattern.

Need a table? Paint an outdoor tray table and set it beside the chair.

Bored by plain white cushions on your chairs? Cover them with citron dupioni silk or linen and stamp or stencil the fabric in tone-on-tone color.

Need yet another table? No problem. Paint the base of a secondhand find and cover the top with a sheet of copper. You can see where this is going. And it all started with one little picture. (For the completed bookcase and a view of the sunroom, see the photo on p. 36.)

WORKING WITH ACRYLICS

In this book, I've limited the projects to those created with acrylic mediums: paint, ink, and stain. There are several reasons for this, not the least of which is environmental concern. Acrylic mediums are less hazardous than many other mediums, and cleanup is a snap with just soap and water or rubbing alcohol.

Types of acrylic paints and finishes

Acrylic paints work well on almost any surface, including fabric, leather, suede, and wood. The paints dry quickly and are practically odorless. And they are readily available in a huge variety of colors and finishes, including opaque, transparent, metallic, iridescent (pearlescent), and interference.

OPAQUE PAINT This type of paint completely obscures what it covers so that little or none of the underlying finish shows.

TRANSPARENT PAINT Transparent paint is sheer and provides a view of what it covers. An example of this would be the wood grain showing through on a piece of furniture.

REFLECTIVE FINISHES These finishes include metallic, iridescent (pearlescent), and interference paints, which reflect light by means of an additive combined with the paint. Examples of these additives are mica and metal flakes. Acrylic iridescent mediums achieve a pearlized finish by the addition of mica flakes to the base color. Interference colors are like iridescent colors, but they have a softly colored pearlized finish rather than the silvery pearl of iridescent colors. For an example of a project painted with transparent paint and glazed with a light metallic bronze finish, see the photo of the Jungle-Influenced Bookcase on p. 38.

Paint additives

There are products you can add to acrylic paint to affect different aspects of its workability.

EXTENDER To slow the drying time of paint and increase the length of time it can be left on the palette without drying out, add extender medium (also called retarder or gel retarder) to the paint as shown below, following the manufacturer's instructions.

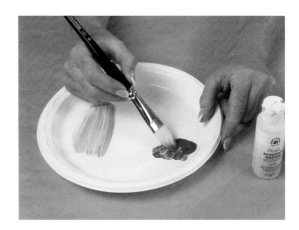

Adding extender can change the color of the paint. The more extender that is used, the lighter and more transparent the paint color. For example, the darker paint swash at the top of the photo on p. 18 shows paint that has been diluted with extender in a 1:1 ratio, and

the lighter swash at the bottom shows paint diluted in a 1:5 ratio.

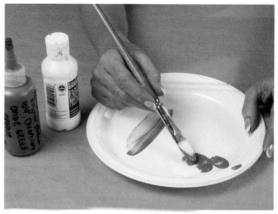

FABRIC MEDIUM To increase adhesion and open time (the time before the paint sets) and to enhance the workability of the paint when painting on fabric, add fabric medium (sometimes called textile medium) to the paint, according to the manufacturer's instructions. Adding fabric medium has other advantages: It reduces or eliminates the stiffness, running, and bleeding associated with acrylic-painted fabric and prevents skipping and scrubbing, which give an uneven look to rough-textured fabrics.

There are several brands of textile medium on the market, and all work well. Fabric medium can be added directly to the palette to blend with color, but usually it is added to the paint in a ratio of 1:2; that is, 1 part medium to 2 parts paint. Changing this ratio creates different effects. For example, to get transparent dye-

like washes or watercolor effects, blend in a 5:1 ratio with paint; that is, 5 parts medium to 1 part paint.

Artist's Insight I like to premix fabric medium with the paint and test it on scraps of the fabric I plan to use.

Using acrylics on fabrics

Acrylics adhere well to porous surfaces and not so well to shiny, slick ones. Always pre-wash washable fabrics to remove sizing and other finishes. Once painted fabric is dry and heat-set, it is machine-washable, providing the fiber is meant to be washed. To heat-set fabric, see chapter 2, p. 34.

Using acrylics on leather

Acrylics are also easy to use on leather and suede, and because these materials are slightly textured, they'll add another element to the painted effect. However, suede and leather can't be heat-set like fabric. For these, I use a hair

dryer on the high temperature setting for a few minutes. Even on projects that I completed years ago, I've had no trouble with the images fading, flaking, or peeling.

Using acrylics on wood

Wood surfaces need to be prepared properly before they can be decorated. Finished wood furniture needs to be cleaned and stripped of waxes or oils. It may also need light sanding with fine-grade sandpaper to remove surface imperfections or to dull a glossy finish. After sanding, wipe with a tack cloth to remove dust. Alternatively, use liquid sandpaper, according to the manufacturer's instructions.

After completing the decorative part of the project, seal it with at least two coats of transparent protective coating (varnish). Be sure to follow the manufacturer's instructions. See chapter 2, p. 35, for more details on varnishing wood. You can add layers of paint on top of the varnish if you decide to add to your design. Always finish up with a few final layers of varnish to protect your work.

Paint perception

The same paint will look different when applied to different surfaces, textures, and colored backgrounds. For this reason, be sure to test any paint you plan to use on a sample of

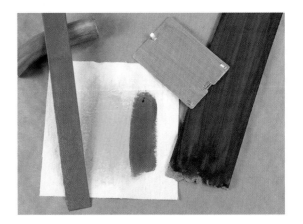

the fabric or other surface you plan to paint.

The photo above shows what different types of finishes look like on different surfaces. Starting at top left, transparent metallic paint on a pipe section, opaque paint on wood lath, transparent and opaque paint on linen fabric, metallic paint on a piece of metal, and transparent paint on fiberboard.

Due to the nature of different fibers and how they are woven, the same color paint and the same image will appear slightly different on different fabrics. Below, you can see how the same color paint looks when applied to (from left) cotton, silk, and linen.

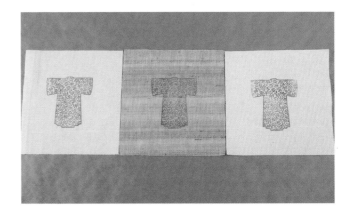

2

painting

painting

PICKING UP A PAINTBRUSH TO PAINT FREEHAND can be intimidating, but don't be daunted. Even if you haven't held a brush since kindergarten, you can produce beautiful images with a little practice. The information in this chapter will help you master basic painting techniques. You will learn what supplies are needed, which brushes to use, how to make different brushstrokes, and how to prepare, handpaint, and finish a project.

To spark your imagination, I have included a variety of handpainted furniture and garments that you can duplicate using these techniques, but please don't limit yourself to the projects presented here. Instead, personalize your home and wardrobe with images that appeal to you. If you have a hard time visualizing images, try adapting images from everyday sources, such as photographs, postcards, greeting cards, and magazines. For example, the initial idea for the motifs used on the silk dupioni vest shown on p. 40 came from a greeting card; the stylized, brilliantly colored critters simply grew from there. I made the garment in silk, which gives it a more luxurious quality than if a more common fabric had been selected. The lesson to learn from this is not to limit yourself to the fabrics you're familiar with: A vest only takes a yard

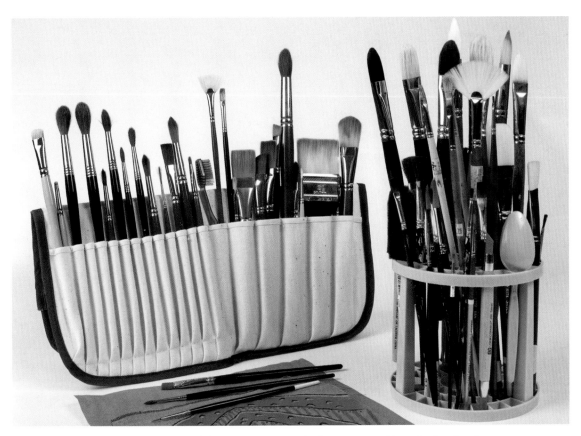

Purchase brushes in different sizes and shapes to serve particular purposes. Clean the brushes in warm, soapy water or alcohol; rinse them in clear water; and shape the bristles while still damp. Allow to air-dry, then store the brushes as shown above.

or so of material, so an investment in a luxury fabric like silk won't break the bank.

Take a look at the finished pieces included in the Painting Gallery, pp. 36–43, to get some ideas, then pick up a paintbrush and make a beautiful project of your own.

MATERIALS AND SUPPLIES

Although painting doesn't require special train-ing to achieve successful results, you'll be more pleased with your work if you have a basic knowledge of what tools and materials to use and how to use them.

Paintbrushes

Good quality brushes make painting a pleasure, so buy the best you can afford and take care of them. Use brushes designed specifically for acrylic paint or those for both acrylic and oil paint; these come in a variety of sizes and shapes. To learn about specific types of brushes, see Types of Brushes on p. 25. You don't need

a different brush for every task, but it makes sense to use a brush appropriate for what you are painting. The size of the brush should fit the task: It takes a long time to fill in a big image using a small brush. Before using a new brush for the first time, rinse it in water to remove the sizing that protects the bristles during shipping.

Add to your brush collection as you are able. I've added a variety of brushes over the years and continue to collect different sizes and shapes. Stiff, short-bristled nylon brushes, called *scrubbers,* work well on heavy-weight and textured fabrics. Softer brushes are good for painting on finely woven and knit fabrics. Sponge brushes are good all-purpose brushes that come in a variety of widths, are inexpensive, and can be discarded when the project is completed.

Acrylic paint

The consistency of the acrylic paint you use is very important, so be sure to use good quality paint with the consistency of thick cream. You can thin a too-thick paint with water or with one of the painting mediums. If you use water for thinning, add the water a little at a time because too much water will break down the integrity of the paint. Fabric mediums retain the quality of the color, but the color becomes more sheer as more medium is added to the paint.

High temperatures and humidity or excessive cold adversely affect the qualities of the paint, so take into consideration the conditions before starting your project. For more information on the types and finishes of acrylic paint, see chapter 1, p. 17.

Fabric medium

Adding fabric medium (sometimes called textile medium) to the paint increases the adhesion of the paint and the "open time"; that is, the time before the paint sets. Fabric medium also helps eliminate the stiffness, running, and bleeding associated with painted fabric, and it helps prevent skipping and scrubbing, which give an uneven look to rough-textured surfaces. Before you begin your project, mix different ratios of paint to fabric medium to see what works best for you. Although water can be used to thin the paint, it will weaken the color intensity much more than a fabric medium will. For more information on using fabric medium, see chapter 1, p. 18.

Extender

Adding extender medium to the paint slows drying time and increases the length of time paint can be left on the palette. You can use

Types of Brushes

Practice your painting technique with different brushes to determine which ones give you the desired effect.

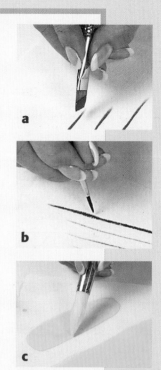

FLAT BRUSHES

Flat brushes are versatile; they are used for filling in areas, for shading, and for making decorative strokes. The rectangular shape makes a stroke the width of the bristles or, if held in a perpendicular position, a fine line (see photo a).

ROUND BRUSHES

The fine-point tip of a round brush makes it easier to produce short, crisp lines and to get into small areas. Changes in pressure on the bristles will create varied strokes, from thick to thin (see photo b). Round brushes are also used for filling in wide areas (see photo c).

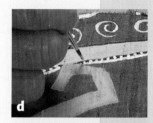

LINER BRUSHES

Liner brushes have fine tips and are used for lettering and painting details. For best results when using a liner brush, thin paint to an inklike consistency to get a smooth application. Load the brush fully, but don't twist the bristles in the paint, which can distort the tip. To paint, hold the tip of the brush perpendicular to the surface being painted (see photo d).

FILBERT BRUSHES

Filbert brushes are flat, wide-bristle brushes with tapered tips. These brushes are terrific for filling in large areas (see photo e). Because the filbert brush has a tapered tip, it also offers control when adding detail (see photo f).

FAN BRUSHES

The tip of a fan brush is flattened by the ferrule and separates into segments when paint is applied. Paint can be applied with the brush tips to create a crescent-shaped pattern, or the tips can be dragged for a more whimsical look (see photos g and h).

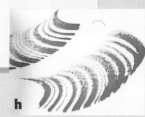

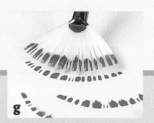

extender as the diluent (diluting agent) for floating, shading, and highlighting (described on p. 33), and to thin paint to a more transparent state without altering the color. You can also use extender along with fabric medium to increase open, or drying, time when painting on fabric. For more information on using extender, see chapter 1, p. 17.

Palette

You'll need a palette to hold the paint while you work. Plastic or plastic-coated paper plates make inexpensive palettes. When you are through painting, just discard the plate and start fresh next time. Shallow disposable food trays also work well.

Artist's Insight I always use a white palette so that I can see color blends more easily.

Other supplies

In addition to the supplies listed above, keep a water container handy to rinse your brushes, and have paper towels ready to absorb excess moisture. Wear latex gloves, if desired, to protect your hands from stains, and wear an apron to protect your clothes against splatters.

CHOOSING A PROJECT

There are a range of options when selecting a project for painting; the Painting Gallery, pp. 36–43, includes examples of handpainted furniture, garments, and accessories. For more ideas on choosing a project, see chapter 1, p. 13. If you choose to paint a piece of furniture, you can either start with new, unfinished wood or use an old painted piece, as long as the surface is properly prepared (as described on pp. 27–29). If you decide to paint on fabric, here are some guidelines to help you make your fabric selection.

Choosing fabric

I especially enjoy painting on cotton, linen, and silk. Paint adheres well to the surface of these natural fibers, and these fabrics also hold fine details well. Smooth, tightly woven fabrics allow for more detail when painting, stamping, or stenciling, whereas coarse, loosely woven fabrics, such as heavy linen, break up the image. Avoid using fabrics that have been treated with a stain-resistant finish, such as Scotchgard®, or with a water-resistant finish because these surfaces will not hold paint. When in doubt about a particular material— you guessed it—test a sample to see if the paint will adhere.

PREPARATION

Whether you're painting fabric or furniture, the surface preparation is key to a successful project and has a direct bearing on the beauty of your finished creation.

Preparing fabric

Proper preparation of fabric is critical to the success of your project. If you're using fabrics that are not washable, such as leather, wool, and some silks, always check paint adhesion by testing the paint on a sample piece of fabric. Whether you plan to handpaint, stencil, or stamp the decorative work, follow these easy steps.

1. Washable fabrics should be washed to remove sizing and other finishes. Do not use fabric softeners in the rinse cycle or in the dryer because these interfere with paint adhesion. Dry the fabric and press out any wrinkles before proceeding.

2. To increase adhesion and enhance the workability of the paint on all fabrics, add fabric medium according to the manufacturer's instructions.

3. To absorb excess paint and help prevent bleeding, cover the table or work surface with old towels, unprinted newsprint, or muslin. Stretch out and pin, staple, or tape the fabric to the padded work surface.

> *Artist's Insight* When painting a large piece such as a duvet cover, I set a sheet of plywood on top of my 42-inch by 72-inch cutting table. For smaller projects, I use a cutting table or a sheet of foam core, padded as described.

4. If you want to paint yardage in random patterns, just pick up your brush at this point and start painting. If you want to paint specific images in specific locations on an unfinished garment or other fabric project, use graphite paper to trace the pattern pieces onto the fabric, allowing generous seam allowances. Then transfer the design images onto the fabric. For specific information on transferring images, see chapter 1, p. 15.

Preparing new wood

The preparation of your wood piece will differ somewhat, depending on whether your project will have a stained background or a painted one. Regardless of which you choose, new wood will first need to be sanded and sealed.

1. The surface of the wood must have a smooth finish. If the wood is rough, begin

with medium-grade sandpaper (about 120 to 150 grit). If it's fairly smooth, begin with an extrafine- or an ultrafine-grade paper (about 320 to 400 grit). Wipe with a tack cloth to remove dust. Finish sanding with a 600-grit paper. Sand with the grain of the wood, checking to make sure the surface is completely smooth. Wipe with the tack cloth to remove all dust particles. See the chart on p. 30 for help on choosing the right grit sandpaper for the job.

2. If you will be painting the background, seal the wood with a primer-sealer. Select a light or dark color depending on the color of your background paint. If you want the wood grain to show through, use a pre-stain conditioner instead of a primer-sealer. Sealing may raise the grain of the wood, so allow the sealer to dry, sand with fine-grade paper, wipe with a tack cloth, then repeat the process. You can speed up the drying process by using a hair dryer, but don't hold the dryer too close, or the paint will bubble.

3. If you are staining the wood or glazing it with diluted paint, do this step now. Allow the stain or paint to dry, then lightly sand and wipe clean with a tack cloth. Repeat, if necessary. Seal with at least two coats of varnish, lightly sanding between coats and after the final coat to prepare the surface for decorative painting. If you are painting the background, apply your base coat and allow the paint to dry. For larger pieces, use latex acrylic paint, which is less expensive than the small containers of decorative acrylic paint. When dry, lightly sand the surface and wipe clean. Repeat, if necessary. The wood is now ready for decorative painting.

When decorating a piece of furniture, you can use the back of the piece as the testing surface for your technique—the close-up photo on the facing page shows how I considered several options before making my final choices for the bookcase shown on p. 38.

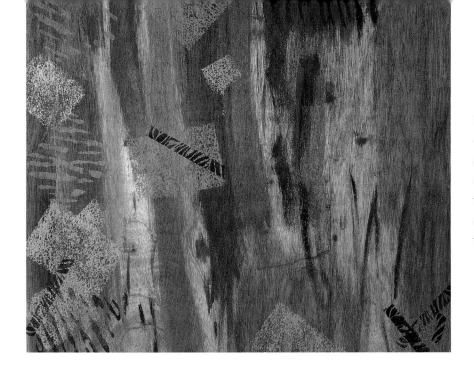

Before starting a project, test paint colors and design motifs on a sample of the surface they will be on, as I did on the back of this bookcase.

Preparing painted wood

If the paint is not in good condition, you may need to strip it down to bare wood and proceed as for new wood. There are a variety of products available for stripping wood. Ask for product recommendations at your local paint store or home improvement center, and be sure to follow the manufacturer's instructions carefully. If the piece has isolated sections of loose paint, and you do not mind a rougher finish, remove loose paint with a paint scraper, then smooth the edges with a medium-grit sandpaper before proceeding.

1. If the paint is in good condition, clean the surface of the painted wood to remove dirt and oil, then lightly sand with fine sandpaper. Wipe with a tack cloth to remove all dust particles from the surface.

2. Next, apply a base coat. If the piece is large, use latex acrylic paint, which is less expensive than the smaller containers of decorative acrylic paint. If the piece is small, using decorative acrylic paint is fine. Let dry, then lightly sand and wipe clean with a tack cloth. Repeat if necessary. The piece is now ready for decorative painting.

Choosing sandpaper

Wood pieces need to be sanded to smooth surface imperfections, to remove loose or peeling finishes, and to dull glossy surfaces to prepare them to accept new finishes. By sanding a piece properly, you'll ensure that the bond that forms between the paint and the surface is a secure one. The chart on p. 30 will help you choose which grade sandpaper to use and when to use it. Although there are many

Sandpaper Grades and Uses

Grit	Uses
Medium/120–150 grit	smooth or remove old paint
Very Fine/220 grit	light sanding between stain and sealer
Extrafine/320 grit	sanding between coats for final finishing
Ultrafine/400–600 grit	final sanding before finish coat(s); wet-sanding

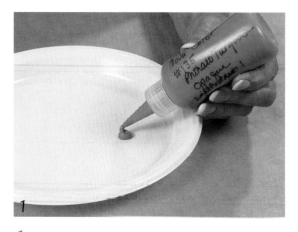

1. Squeeze a small amount of paint onto the palette. Don't overdo it; you can always add more.

grades of sandpaper available, these are the ones I use most often. Be sure to use a tack cloth and wipe in a blotting motion to remove particles and debris before applying your finish.

PAINTING TECHNIQUES

Before applying paint to fabric or wood, first select a brush that is appropriate for the technique, then practice loading the brush and making clean, crisp strokes. When you have finished painting, wash all tools in warm, soapy water. Rinse well and air dry.

Loading the brush

Before you begin, rinse any new brushes to remove the sizing and make sure the paint is well mixed. For ease of use while working and to save a lot of time, transfer the paint to squeeze bottles.

2. Wet the brush before loading it with paint and remove the excess by gently blotting the brush on a paper towel, as shown below. This step will help the paint flow more smoothly. Determining how much water to leave in the brush is a matter of trial and error. Too much water will dilute the paint; however, if the bristles are too dry, they will absorb moisture from the paint and make it too thick to flow easily. Continue to blot the wet brush until the bristles lose their shiny appearance.

3. Load the brush by pulling paint from the edge of your paint puddle on the palette. Dipping the brush into the puddle will pick up too much paint and distort the tip.

3

4. To distribute the paint on the bristles, make short, straight strokes in the same spot on your palette until the paint is evenly worked into the brush. Repeat on the other side of the brush. A well-loaded brush will have paint evenly distributed short of the ferrule (the metal part that joins the handle to the bristles).

4

Making brushstrokes

Strokes are created by varying the pressure applied to a loaded brush. The motion comes from moving the arm and wrist, not the fingers.

FINE LINES Begin by practicing your technique with a liner brush (shown on p. 25), which is invaluable for lettering, outlining, and other delicate detail work. Hold the liner, fully loaded, perpendicular to the painting surface and paint in a steady motion, slowing down when making a curve to allow the paint to flow smoothly.

FILLING IN Next, practice with both round and flat brushes to create clean, even strokes. To fill an area, make crisp strokes side-by-side rather than randomly scrubbing paint onto the surface. Here, a flat brush is used to fill a wide area.

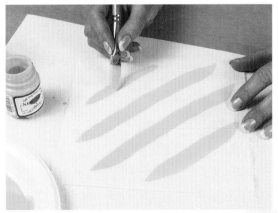

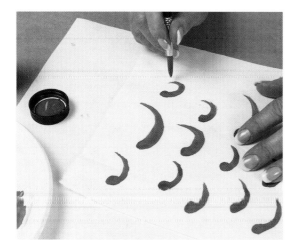

S STROKE To make an *S* stroke with a round brush, begin on the point of the brush. Gradually increase pressure as you move into the first curve of the *S* and maintain even pressure as you continue into the second curve. Gradually release pressure through the second curve to end back on the point of the brush.

COMMA STROKE For decorative work, the most common strokes are the comma stroke and the *S* stroke. To make the comma stroke using a round brush, begin on the point of the brush. Press gently to flatten the brush, then pull the brush toward you in the shape of a comma, releasing pressure until you are back on the point of the brush.

To make a comma stroke with a flat brush, repeat the technique, but begin and end the comma stroke on the chisel edge of the brush.

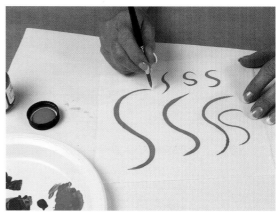

When using a flat brush to make an *S* stroke, use the same technique but begin and end on the chisel edge of the brush.

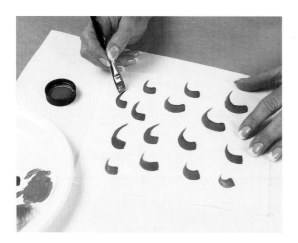

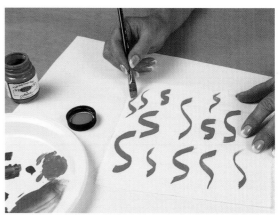

Shading and highlighting

The technique of "floating" color on a surface is used to shade and highlight a base color or to add interest to the painted images in a design. To begin, dilute the base-color paint on the palette with water, fabric medium, or extender. Then side-load a flat brush by dipping one corner into the diluted paint. Blend the paint into the brush by stroking the brush on the palette until the color has reached the desired intensity on the opposite side of the brush.

The color should not be distributed evenly across the brush, but should fade in intensity from one side to the other. To shade, use a darker color paint than the image's base color. To highlight, float a lighter color over the base color.

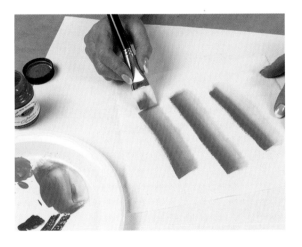

Applying the paint

Once you've prepared the surface of the project and have practiced how to load a brush, make brushstrokes, and shade and highlight an image, you're ready to begin painting. Read through the steps that follow to learn the techniques for applying paint to a project. If you've never painted freehand before, be sure to practice your technique before starting, and always try out your idea and paint colors on a sample before beginning the actual project. (To see the completed handpainted garment shown on p. 34 and learn more about the project, turn to p. 40.)

1. Begin by choosing your design and marking it on the surface to be painted. To do this, first sketch the design on paper and fill it in with colored pens or pencils, matching your chosen paint palette as closely as possible. Next, trace the sketched images onto tracing paper, then use graphite paper to transfer the design lines onto the project. For specifics on how to do all this, see chapter 1, pp. 14–15.

When you are painting a garment that you are sewing yourself, first trace the pattern pieces onto the fabric, allowing generous seam allowances; then use graphite paper to transfer the images onto the fabric. Usually, all painting is done on the fabric before the garment is

sewn. But in cases where you want to paint a continuous design and the design will cross a seam, join the seams of the garment before—not after—you begin painting to avoid sewing through the design later.

2. Apply paint to the project, using your colored drawing as a guide. Begin by filling in the large areas of your design with the base colors. When filling in large areas, such as the design on this vest, begin working from left to right if you're right-handed; if you're left-handed, work from right to left. That way, you won't be reaching over wet paint to work on the next area.

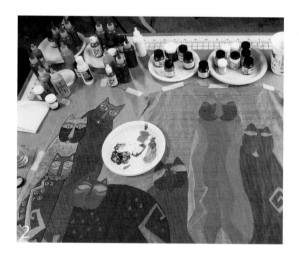

3. After filling in all the large areas with paint, do the detail work and any shading or highlighting. If you are working with fabric, keep a swatch of the garment fabric handy to

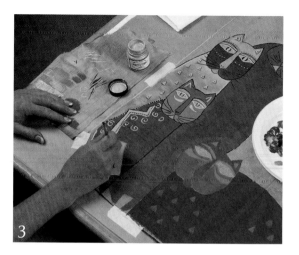

test the brushstroke appearance and to see how the color "reads" so there will be no surprises.

FINISHING

After you have finished painting, you will need to protect your work. Designs on fabric will need to be heat-set, while those on wood will need to be varnished.

Heat-setting fabrics

When the paint is completely dry, heat-set the fabric on both sides, using a pressing cloth or parchment paper to protect against scorching. Use as high a temperature setting on your iron as the fabric can tolerate, and press (without steam) for 30 to 45 seconds. For large pieces of fabric, place the fabric in the dryer and heat-set at the highest temperature setting. For leather and other fabrics that cannot tolerate heat-setting with an iron, a hair dryer on high set-

ting will do the trick. After being heat-set, the painted fabric is ready to be used and is washable or dry-cleanable.

> *Artist's Insight* When painting on fabrics, I often use a hair dryer to speed the drying process before heat-setting.

Varnishing wood

After completing your design, varnish the piece with at least two coats of water-based varnish. Allow the varnish to dry, and sand lightly between coats. Varnish comes in glossy, matte, and satin finishes. A *glossy* finish is high shine, a *matte* finish is muted, and a *satin* finish is in between. If the piece is going to be exposed to the weather, be sure to use a varnish suitable for the outdoors. Allow the varnish to dry thoroughly before using the piece.

> *Artist's Insight* I prefer to use a satin-finish varnish for furniture because its slight gloss highlights the finish and gives it a richer look without reflecting too much light, which might obscure details.

WET-SANDING Wet-sanding is another method for sanding between the final layers of varnish. It will smooth any imperfections in the surface of your project and create a flaw-

Handy Tips

▲ Don't use watercolor brushes when painting with acrylic paints; these are designed to hold lots of water and pigment and are not suitable for use with acrylics.

▲ Test leather before painting. Sueded leather usually holds paint well, but smooth (napa) leathers often have wax or oil finishes that prevent paint from adhering to the surface.

▲ Avoid painting on woolen fabrics; wool often contains lanolin, which makes adhesion difficult.

▲ Avoid painting on shiny fabrics; such finishes may not allow paint to adhere.

▲ Paint with a light hand. You can always add more paint, but it's difficult to remove paint once it's applied.

▲ Using multiple layers of paint is fine, just be sure each layer of paint is thoroughly dry before continuing, or the paint will smudge.

less finish. To do this, apply the first layer of varnish and allow it to dry. Dip 600-grit sandpaper into mild, soapy water and gently sand the surface, working with the grain. Wipe with a clean, damp cloth to remove any soap film, and allow the first layer to dry. Wipe with a tack cloth, then apply at least one more layer of varnish. Repeat as desired. Do not wet-sand after applying the final layer of varnish.

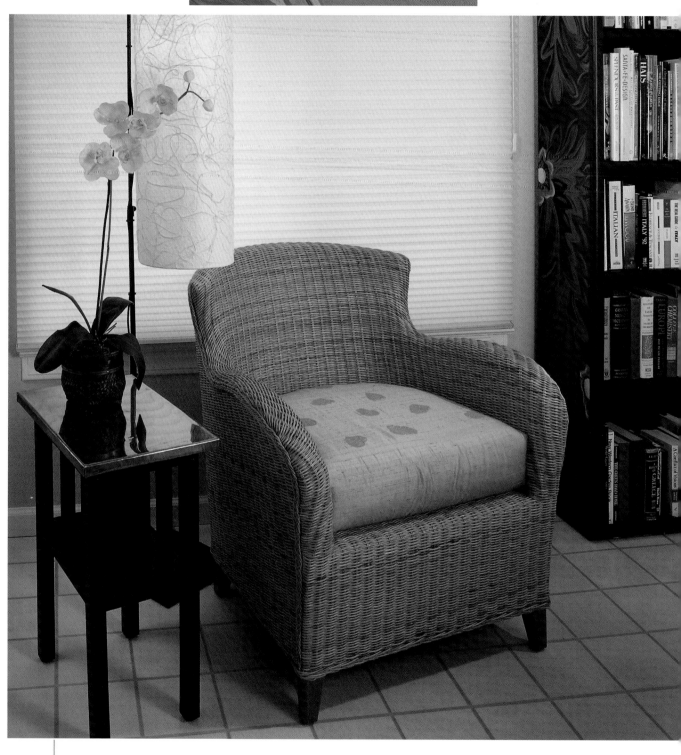

EXOTIC FLORAL SUNROOM BOOKCASE AND TABLE

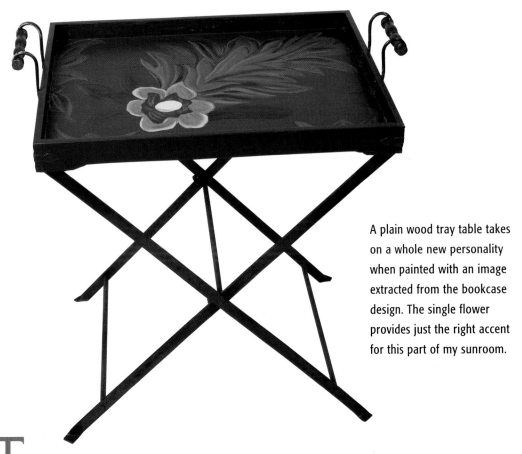

A plain wood tray table takes on a whole new personality when painted with an image extracted from the bookcase design. The single flower provides just the right accent for this part of my sunroom.

The sunroom in my home is always flooded with light, and it makes me happy just to walk into it. When I saw a photo of a floral rug in a catalog, I knew exactly how I wanted to furnish this room: Fill it with things that thrive in sunlight. Using the methods described in chapter 1 on pp. 14–15, I adapted the floral rug design to the bookcase. To keep the focus on the lavish design, I chose an opaque paint for the background to obscure any wood grain. I painted the images in vibrant colors, which remind me of the work of Paul Gauguin in Tahiti. The close-up photo on p. 13 in chapter 1 shows the detail of the brushstrokes, which contribute to the overall look of the piece.

Jungle-Influenced Bookcase

his tallish, narrow bookcase is in a room decorated with a jungle theme. I painted the original medium-oak finish with raw umber paint, then lightly glazed it with metallic bronze to obtain a slight sheen. Random application of both stamped and stenciled motifs imparts a carefree look.

The grain of the wood is still visible through the paint and glaze, as seen in the close-up [ABOVE]. This painted surface makes a terrific background for the sponge-stamped gold squares and the black zebra-esque stencils.

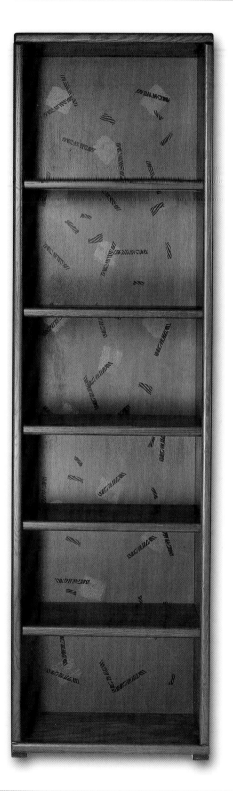

FALL LEAVES SILK SCARF

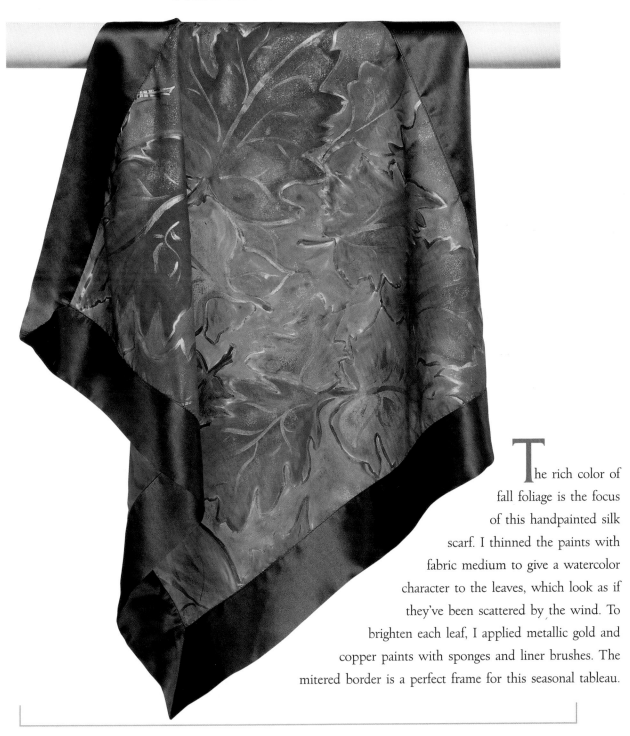

The rich color of fall foliage is the focus of this handpainted silk scarf. I thinned the paints with fabric medium to give a watercolor character to the leaves, which look as if they've been scattered by the wind. To brighten each leaf, I applied metallic gold and copper paints with sponges and liner brushes. The mitered border is a perfect frame for this seasonal tableau.

PAINTED SILK LOS GATOS VEST

The simple silhouette of this collared vest is the perfect foil for the colorful exuberance of the highly stylized cats. The vivid, bright color palette is accented with black and metallic gold paints. To help visualize your color choices, make copies of your design and fill them in with colored pens or pencils.

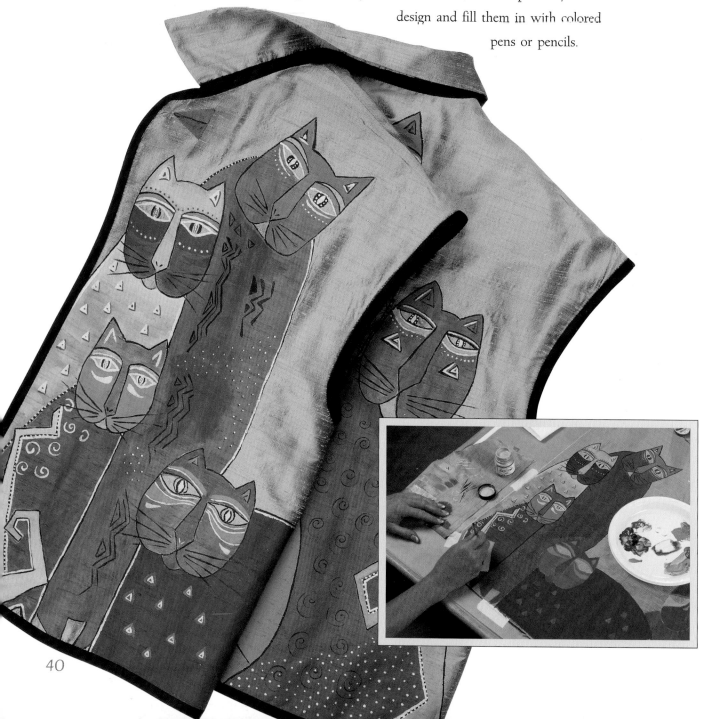

SILK PALM LEAF BAG

Black silk dupioni provides a high-contrast background for the painted palm frond. The color palette looks more complex than it is. The basic palm shape is painted first in olive green, then yellow and black details are added with the chisel edge of a flat brush. Random application of the detail brushwork is more natural than calculated placement because it more realistically mimics what is found in nature.

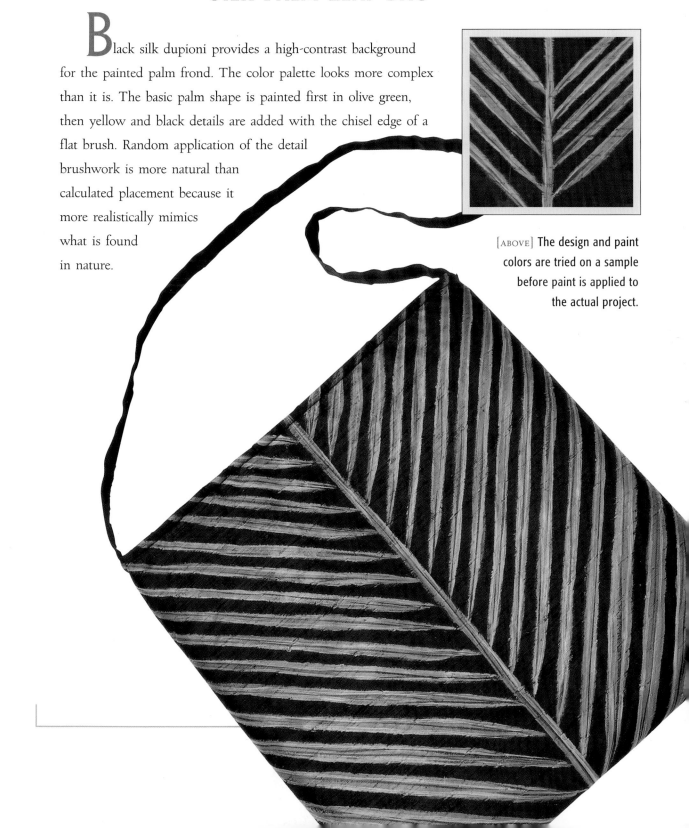

[ABOVE] The design and paint colors are tried on a sample before paint is applied to the actual project.

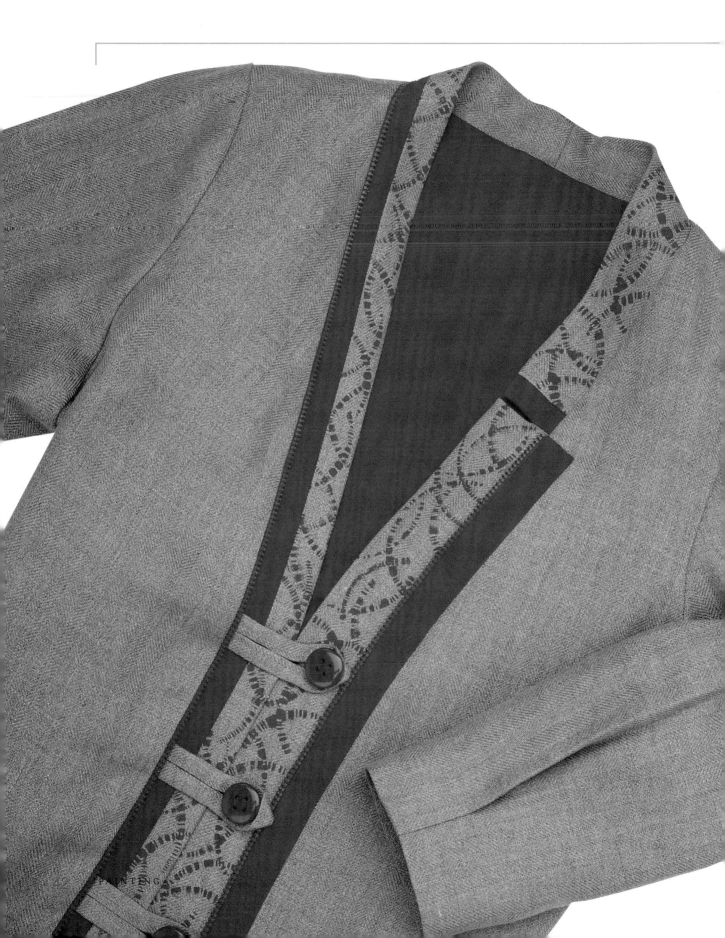

PAINTING

Jakarta Linen Jacket

The natural herringbone linen of this jacket is punctuated by vibrant red details. Opposites on the color wheel, such as this combination, are pleasing to the eye because they create harmony. Separated sport zippers are used as piping and make a surprising, fun trim alongside the handpainted bands and solid-red accents. To paint the bands, I dipped the tips of a large fan brush into paint, then applied the brush to the fabric in randomly overlapping crescents, suggesting the idea of zipper teeth. The close-up view of the back collar shows how the vintage red buttons used on the jacket give it that final dressmaker's touch.

Before working directly on the trim, I practiced using just the tips of a fan brush on a scrap of the jacket fabric.

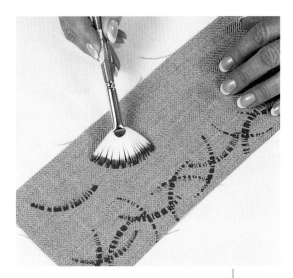

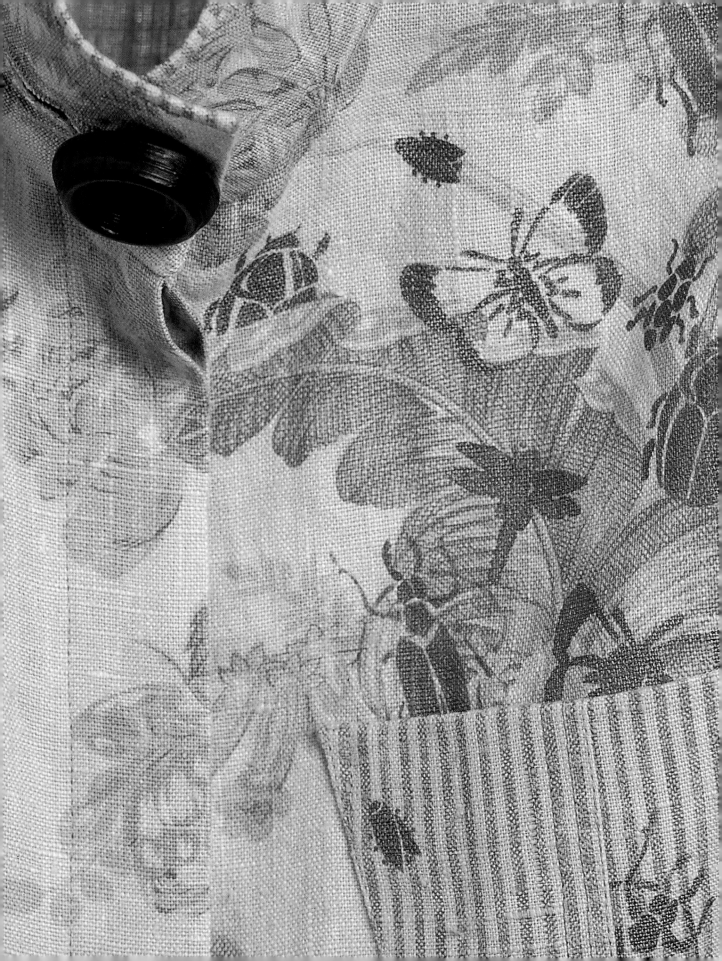

3

stenciling

stenciling

STENCILING, THE PROCESS OF APPLYING PAINT through cutouts in a block-
ing material to create a pattern, is considered the oldest form of printing. In
the Middle Ages, people living in what is now France used the technique to
decorate fabric and household items, such as books, wallpaper, and playing
cards. The technique spread throughout Europe and, as time went on, to the
New World. As American immigrants became more affluent, they adopted
the decorating styles of their native lands and used stenciling in their homes
to mimic the look of expensive European furniture and luxurious wallpapers.
Artisans have continued to develop the technique, applying it to countless
surfaces.

Today, using currently available tool and design options, myriad effects can
be created with stencils. In this chapter, you'll find exciting designs that have
been applied to wood, sisal, and a variety of wonderful fabrics: sheer organza,
silk dupioni, crisp linen, supple suede. The materials used to create the proj-
ects are inexpensive, readily available, and simple to use. The ideas presented
are intended to spark your imagination and encourage flights of fancy. You
can combine elements from the projects featured in the Stenciling Gallery on

Commercial stencils are available in an endless variety of design motifs and can be used over and over, if properly cared for. If you decide to cut your own stencils, just follow the easy steps provided on p. 50.

pp. 58–85, or use them as a jumping-off point for your own creations. The directions and photos will guide you through the stenciling process and help you achieve your artistic vision.

MATERIALS AND SUPPLIES

Using just a simple sponge, acrylic paint, and a few basic stenciling materials, you can achieve successful results on a range of fabrics and wood surfaces. Most of the required supplies are regular household items you probably already have on hand.

Stencils

Wonderful commercial stencils are available, or you can make your own. If you decide to make your own stencils but are using another's design, please respect copyright laws. Consider using images from the public domain, which do not have copyrights. Dover Publications, Inc., which has an extensive catalog, is a good

The drawing (left) was used as the pattern for the long-lasting acetate stencil (center) and for the single-use freezer paper stencil (right).

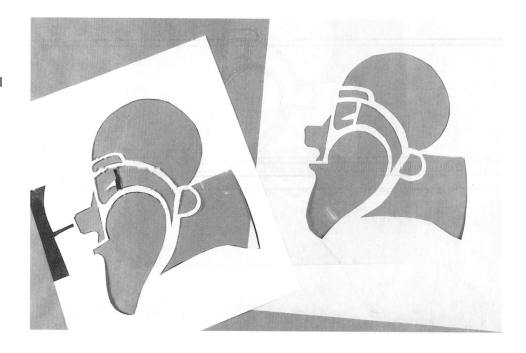

source for copyright-free designs. See the Sources listing on p. 138 for the company's address.

For single-use stencils and very large stencils, I use freezer paper. For more permanent designs, I prefer to use Mylar® sheets or pieces of thin acetate (available in both sheets and rolls) because I can see through them for proper design placement. Acetate sheets sometimes come with a matte side and a glossy side, which has three advantages: the matte side can be drawn on with a pencil and helps keeps the knife from slipping during cutting, while the glossy side makes paint cleanup easier. The thinner stencil materials allow paint to be applied to the surface more precisely. The

photo above shows the original drawing I made for a stencil (left), an acetate stencil cut from that drawing (center), and a freezer paper stencil cut from the same drawing (right).

Some stencils have special purposes. Border and corner stencils are designed to create edges, but they can also be used in other ways for interesting effects. Multiple overlay stencils are used to increase the complexity of a design detail by detail and, usually, color by color. They can also be used to cover the bridges on stencils and to create a continuous pattern.

Instead of using an entire stencil, you may want to use parts of a stencil for your project like I did for the large mirror frame shown on the facing page. To create the look, I used masking tape to isolate one border area at a

time in order to build up a total of five separate borders that together fill up the frame. Some of the stencils used are intended for use as borders, but the wing and sweet pea sections are simply parts of larger images. As you can see from the bottom photo at right, I considered several design combinations before making my final decisions on stenciling the mirror frame.

Artist's Insight When using an acetate sheet, I like to stencil with the glossy side up for ease of cleaning, so I make sure to reverse the design when tracing and cutting it on the matte side.

Paint applicators

You may be familiar with blunt-tipped stencil brushes, which are used with oil paints. But when using acrylic paints, and for all but the largest stencils, I prefer to use fine-grained makeup sponge wedges as paint applicators. They are inexpensive and disposable. I do not recommend using regular kitchen sponges. The holes are too large, and the paint blobs rather than blends on the project surface.

For larger stencils, you can make a "pounce dauber" by folding a fine-grained sponge to create an egg-sized surface and tying it off with rubber bands. Use the excess sponge as a handle. Another handy shape is a flat square of

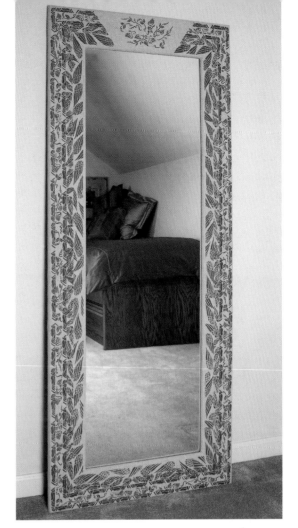

Combine images from different stencils or use parts of a single stencil to create interesting and unique patterns.

Making a Stencil

Stenciling works on the principle of positive and negative space. The positive image (stencil) is cut away from the negative space of the background. To do this effectively and with an appropriate level of detail, you will need to plan bridges in the stenciling material. All the internal detail of the image must be connected to the background by bridges of stencil material or else the design will fall away.

DRAWING THE DESIGN

1. First, determine if the image you plan to use for the stencil is the right size for your project. If not, you'll need to enlarge or reduce the image on a copy machine.

2. There are several ways to make stencils. If using freezer paper, either draw or trace the image and the proposed detail on the paper. Fill in the proposed areas to be cut away with a felt-tipped pen, a marker, or a colored pencil. This allows you to quickly see if the bridging network is intact. If not, add the necessary bridges before you cut. The shiny side of freezer paper resists paint, so keep this side up to design the stencil. To check out the bridging on either an acetate or a Mylar stencil, make a paper copy of the image and fill in with color as described above. Use this colored copy as the cutting template (top photo).

CUTTING THE STENCIL

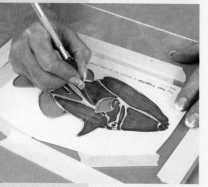

1. Cut the stencil using either a sharp craft knife or a stencil-burning tool. When cutting, place the stencil flat on a cutting mat or on a plate of glass. (If the edges of the glass have not been ground, tape edges with masking tape or duct tape for safety.)

2. If using freezer paper, tape the paper into position on the cutting surface and cut with the knife. If using acetate or Mylar, tape the cutting template to the cutting surface. Position the acetate or Mylar over the template, leaving 2 or 3 inches of overlap around the design, and tape into position. Begin cutting the stencil. For better control, cut away from—not into—a sharp point or corner in the design; there's less chance of overshooting the mark (center photo).

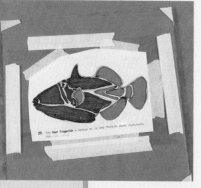
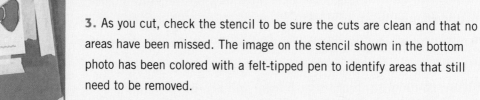

3. As you cut, check the stencil to be sure the cuts are clean and that no areas have been missed. The image on the stencil shown in the bottom photo has been colored with a felt-tipped pen to identify areas that still need to be removed.

fine-grained sponge that has been rolled into a cylinder and secured with rubber bands. Hold this applicator as you would a pencil.

I use sponges on both furniture and fabric, but for very large projects like the sisal rug shown on p. 69, spray paint is the way to go. Direct application of the paint is much more efficient than daubing it on.

To learn about paint, extender medium, fabric medium, and other materials and supplies you may need, see chapter 2, pp. 24–26. If you plan to make your own stencil, read through the steps in Making a Stencil on the facing page to see what other supplies you may need.

Artist's Insight I've found that upholstery shops are a good source for obtaining scraps of fine-grained sponge.

STENCILING TECHNIQUES

With stenciling, you can see how the work is progressing and adjust the paint application as you go. It is a more forgiving technique than stamping, for example, because you have more control. Before you begin, see chapter 2, pp. 27–29 for information on preparing fabrics, new wood surfaces, and painted wood surfaces.

Applying the paint

Wear an apron and, if desired, latex gloves. Using a sponge as an applicator, proceed with the steps that follow.

1. Pour a small amount of paint onto the palette. Add a bit of extender to the paint to increase the open time, or wet the applicator with water and dab it almost dry on paper towels. (Doing this prevents the sponge from absorbing too much moisture from the paint, which will decrease its open time.)

2. Next, dip the sponge into the paint and work the paint into the surface of the sponge by "pouncing" it (using an up-and-down motion) on the palette. The key to successfully applying the paint is using a very small amount of paint and working it well into the sponge.

2

3

5

3. Position the stencil on the surface to be painted, holding the stencil in position by hand, with low-tack tape or with stencil adhesive. If using the adhesive, be sure to follow the manufacturer's instructions.

Artist's Insight Unless the stencil is large and unwieldy, I prefer to hold it in position by hand.

4. Apply paint to the surface using a quick pouncing motion, moving the sponge over the stencil to fill the cutout areas of the image.

5. Keep things clean as you work, since paint on your hands or on the back of the stencil can easily end up on your project. Dried paint won't transfer to other surfaces, but wet paint will, so use baby wipes or paper towels to keep your hands and stencils free of excess paint.

6. When you are finished, clean stencils by gently washing in warm, soapy water. Rinse the stencil in clear water and pat dry. If the paint has already dried on the stencil, use rubbing alcohol for better results. Soak the stencil for a few minutes, then gently scrub the surface

4

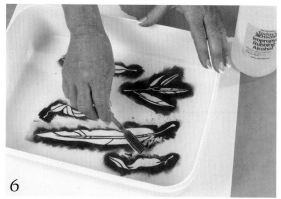

6

with a soft brush. Rinse and pat dry between paper towels. When completely dry, store stencils in labeled file folders or envelopes.

Blending colors

Stenciling with variegated or blended colors personalizes a commercial stencil. Blending, shading, and highlighting add drama and dimension to the image. Experiment to see the effects possible with different methods of blending. You can mix the colors right on the palette to arrive at the exact shade you're looking for, or try the following techniques, which give interesting and subtle results.

Highlight the stencil for a more dimensional look by layering one color directly over another. Since so little paint is being applied at one time, there is no need to let the paint dry between multiple layers. Use a different applicator for each color to keep the colors distinct.

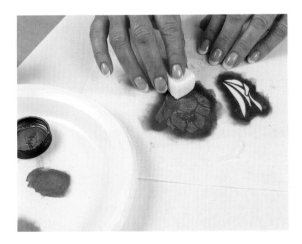

Handy Tips

- If the knife slips while you're cutting a stencil, put clear tape over the slice on both sides of the stencil and recut the area.

- Be sure to use a sharp blade when cutting a stencil. You'll get crisper lines and make fewer mistakes.

- A little paint goes a long way. Always start with less paint than you think you'll need and work it well into the applicator. Be cautious when adding more paint to the applicator; it's easy to add paint, not so easy to remove it.

- If you are repeating a stencil pattern on a project, be sure to apply the paint evenly to each repeat. If paint is not applied evenly, there will be noticeable differences in color intensity and value, which will distract from the overall design.

- Suggest depth and dimension by varying a color's value (its lightness or darkness).

- For more natural effects, combine more than one color with the base color.

- Mistakes happen. If you make a mistake, either incorporate it into the overall design or ignore it. It may not be noticeable to others, and trying to fix it may make the problem worse.

the apron pocket below, I started with ochre paint and blended to blue. Then, with a second sponge, I started with ochre and blended to purple.

Working with multiple overlay stencils

To create a more complex, multicolor design, use stencils that have multiple overlays. Each overlay completes a different part of the image—particular design elements, or colors, or both. Small registration holes at the ends of each overlay allow each succeeding overlay to be accurately positioned so that the final stenciled image looks complete and continuous.

It's much more interesting to the eye to see variations in the surface created by applying additional colors of paint, as shown in the multicolor image above.

To gradually shift the color from one to the next, change paint colors without changing applicators. To do this, apply the lightest color paint first, then dip the same applicator into the next darkest color, and so on. As you can see from the color gradation of the words on

For example, for the stenciled silk valance and duvet cover shown on pp. 60–61, there are

[RIGHT] The pocket on this apron—a stenciled version of the stamped Miyaki-Style Aprons shown on p. 115—shows the gradual color gradation achieved by using blended paint colors.

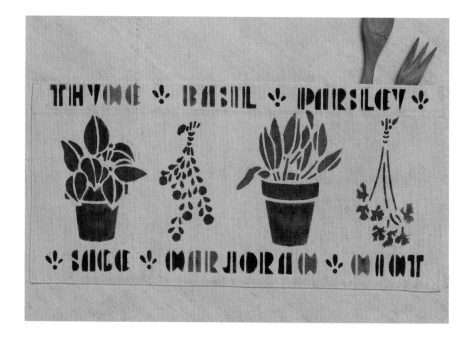

three overlays that combine to produce the twisted jungle vine image. The 8-foot valance and twin-sized duvet cover required several repeats of the stencil. To do this most efficiently, I stenciled all repeats as follows.

1. First I used overlay #1 and the base-color paints to stencil all motif repeats.

2. Then I switched to overlay #2, aligned the registration holes, and stenciled other elements in the image, which gave it a more complete, continuous look.

3. Finally, I used overlay #3 to stencil in tendrils on the vines and veining details on the leaves.

4. You can see in the photo below how the detail and shading in the vines and foliage creates depth and perspective.

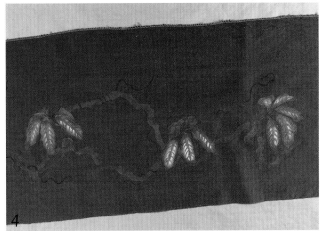

Super Stenciling Ideas

The variations possible with stenciling and the items that can be used to create patterns are unlimited. Here are a few ideas to get you started.

Use paper doilies as stencils to make interesting patterns.

Use a torn cardboard edge to make a great border.

Try reversing the stencil to vary the image.

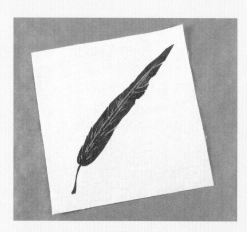

For small details and highlights, try hand-painting with a brush. For example, I used a liner brush and gold metallic paint to transform a eucalyptus leaf into a feather.

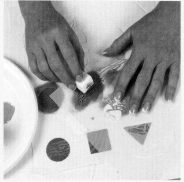

Lay a second stencil on top of the first to add dimension to an image. Here, the basic shapes (circle, square, and triangle) have been stenciled in green. To create a pattern within the shapes, a second stencil of seaweed is laid on top of the first stencil, then bronze paint is applied.

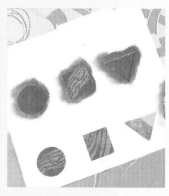

This photo shows the completed image, as well as other images created in the same way.

Finishing

For additional information on how to heat-set fabrics, see chapter 2, p. 34. For details on how to finish wood projects, see chapter 2, p. 35.

1. For fabrics, allow the paint to dry thoroughly, then heat-set, using a pressing cloth, Teflon® pressing sheet, or parchment paper and an iron set at high temperature with no steam. Once heat-set, the fabrics are ready to use.

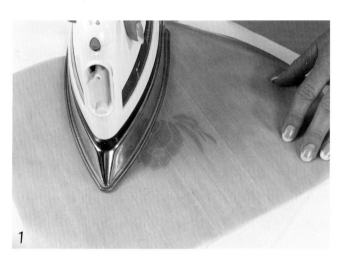

1

2. For materials such as suede that can't be pressed with an iron, use a hair dryer set at high temperature to heat-set the paint.

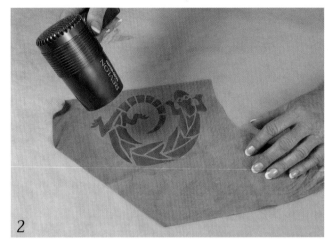

2

3. For large pieces of fabric, place the fabric in the dryer and heat-set at the highest temperature setting.

4. For wood surfaces, seal the painted surface with varnish, sanding between coats.

Artist's Insight Although a stenciled image is permanent once it has been heat-set, I like to turn washable garments inside out when washing them to reduce abrasion.

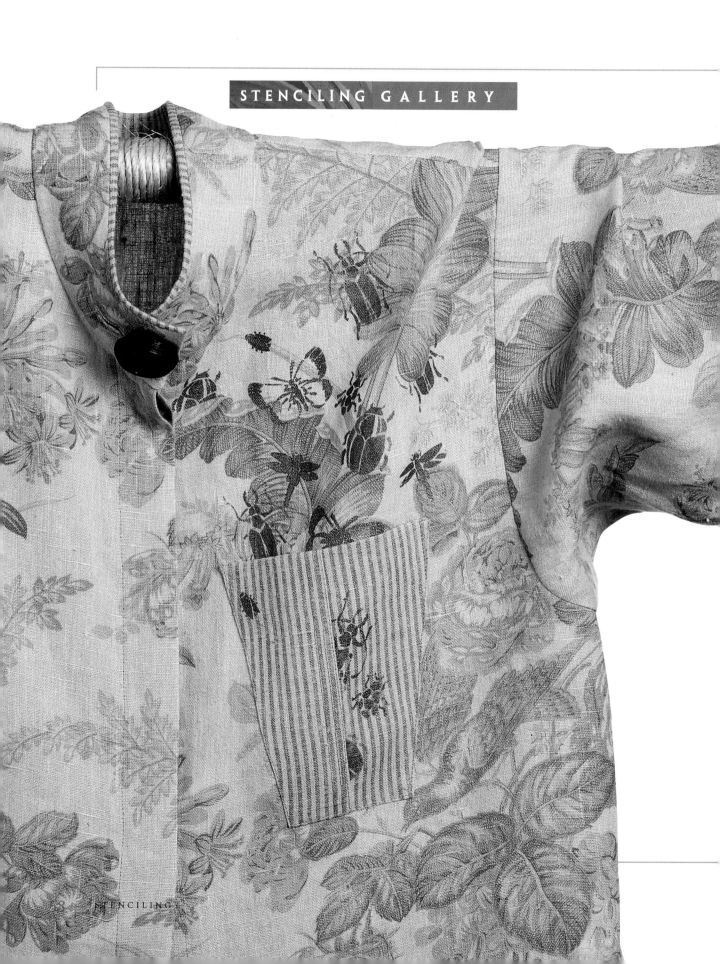

SUMMER SWARM ENSEMBLE

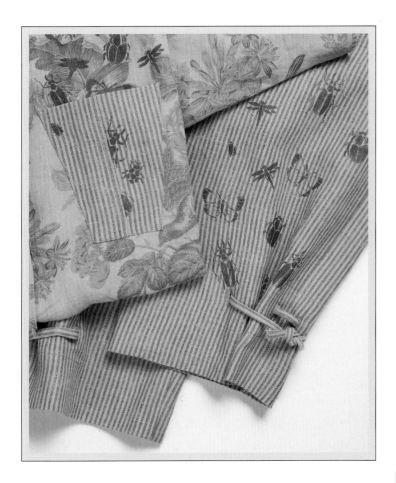

Summery, striped-and-floral linen in green and yellow turns whimsical when a pocket houses a swarm of stenciled insects. The metallic olive paint has just the right touch of bronze to catch the light. When motifs are to have a specific placement on a garment I'm making, such as the bugs on this ensemble, I first cut the pattern pieces and mark the seam allowances. This shows me exactly what I have to work with so that I can plan motif placement accordingly.

On this linen top, I marked the placement of the pocket since it is an integral part of the design. As you can see in the photo at [RIGHT], I added more whimsy with a second release of insects; these are escaping from the folds by the left calf on the pants.

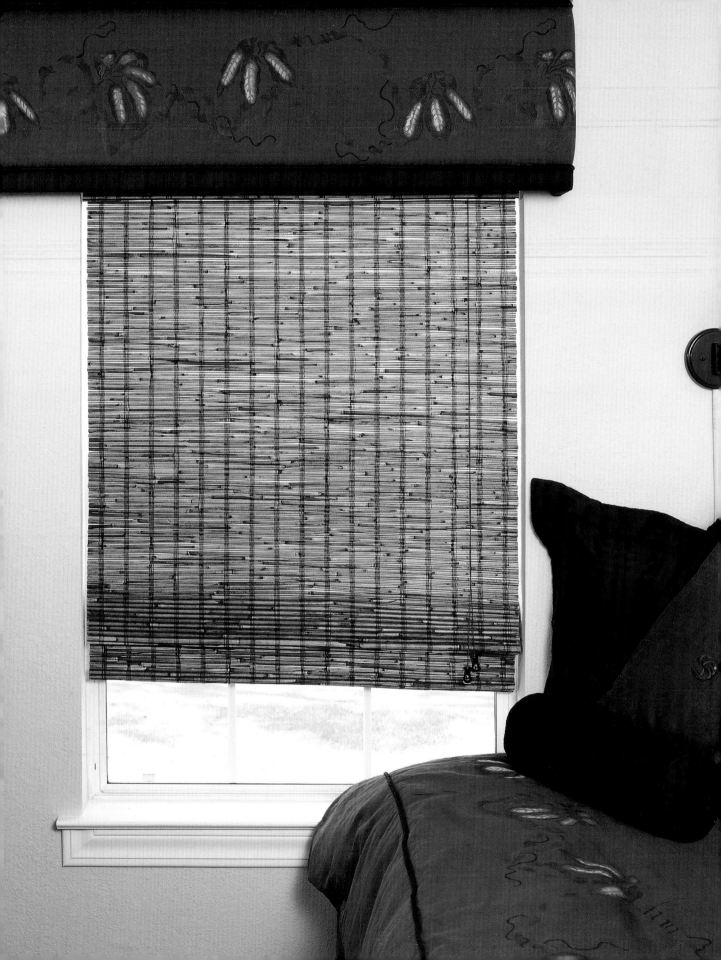

JUNGLE VINE DUVET COVER AND VALANCE

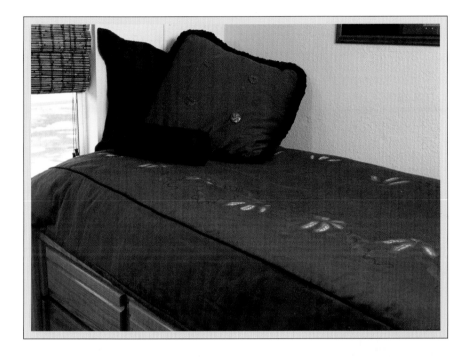

[LEFT] The duvet cover is outlined with a border of twisting vines, a simple repeat of the valance stencil design. The close-up view of the valance [BELOW] shows the wonderful, rich texture of the fabric and the shading on the stencil, which adds a lifelike quality to the images.

Rust-colored, washed silk dupioni is the background for the twisting jungle vines stenciled on both the valance and the duvet cover. To create the images, I used a stencil with multiple overlays, which fill in the different parts of the pattern so that no stencil bridges are apparent in the completed motif. I also used the multiple-overlay stencil because the pattern can be repeated continuously with no break in the design—a perfect choice for large projects such as these.

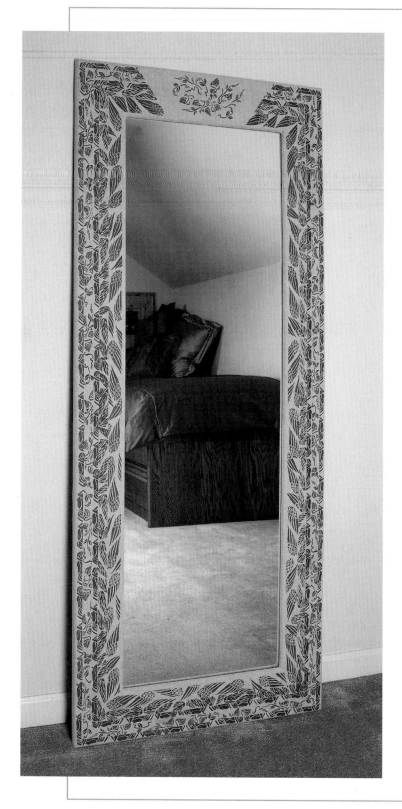

BORDERS MIRROR FRAME

This oversized mirror with a stenciled linen frame is the focal point of a bathroom, where it covers one wall. At the center top of the frame, a sweet pea and vine stencil were combined to create a profuse bouquet, then the sweet pea portion was repeated to make a segment of the border. Repeating an image, as I did here, unifies and strengthens a design.

If you are covering your own frame, be sure to allow enough fabric to wrap to the back along the inside and outside edges. Use spray adhesive to adhere the fabric to the frame and staple to secure.

GILT PIPED VEST

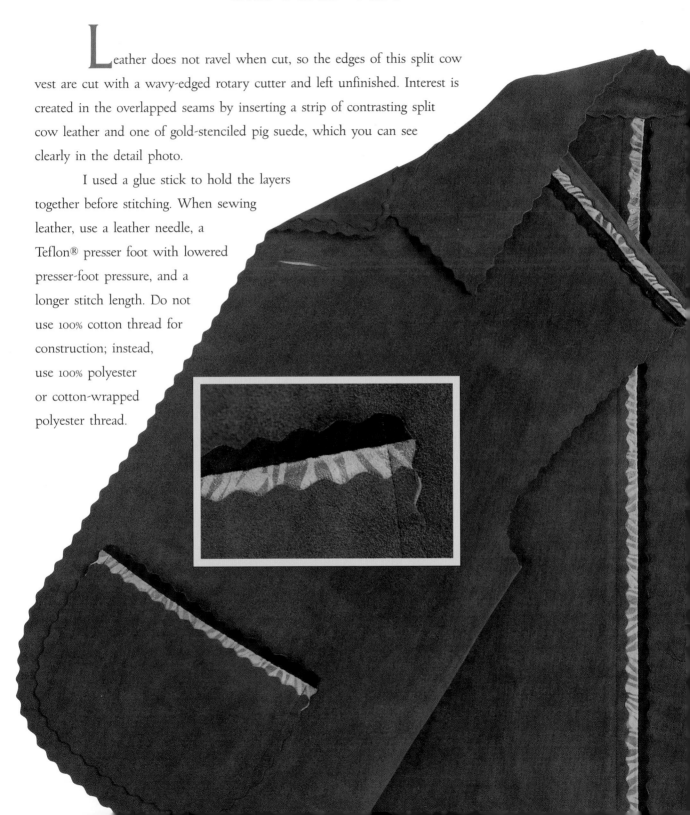

Leather does not ravel when cut, so the edges of this split cow vest are cut with a wavy-edged rotary cutter and left unfinished. Interest is created in the overlapped seams by inserting a strip of contrasting split cow leather and one of gold-stenciled pig suede, which you can see clearly in the detail photo.

I used a glue stick to hold the layers together before stitching. When sewing leather, use a leather needle, a Teflon® presser foot with lowered presser-foot pressure, and a longer stitch length. Do not use 100% cotton thread for construction; instead, use 100% polyester or cotton-wrapped polyester thread.

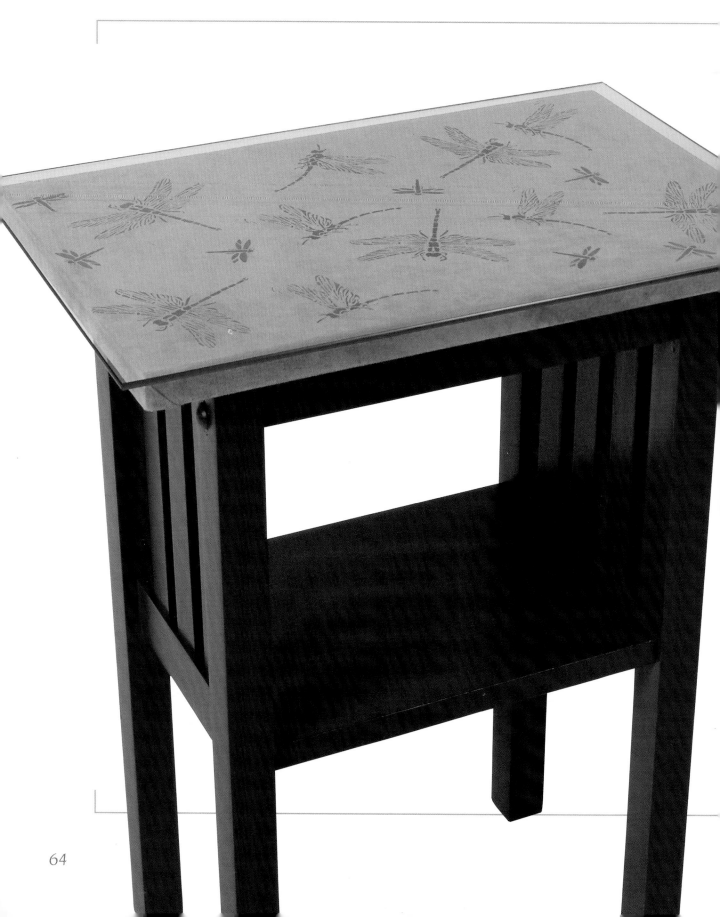

DRAGONFLY SUEDE TABLE

Stenciled dragonflies flit across the surface of this suede-topped occasional table, which has been covered with a sheet of inexpensive glass to protect it. The lighter color value of the avocado suede makes the top seem to float above the deep-toned base. Highlighting the wings and bodies of the dragonflies with metallic paints (as seen in the detail photo) gives the stenciled images the luminous quality of real dragonflies. The motif is repeated on the coordinating curtains, pillows, and chair pads in this bedroom, shown on pp. 106–109.

Here, I'm highlighting the wing tips of a dragon-fly with bronze metallic paint. The motif on the right has already been highlighted with olive metallic paint.

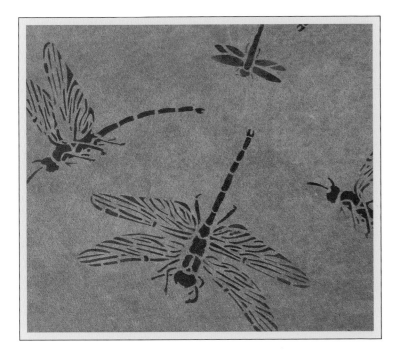

A highlighted image is subtle, not garish, and has much more dimension than a single-colored image.

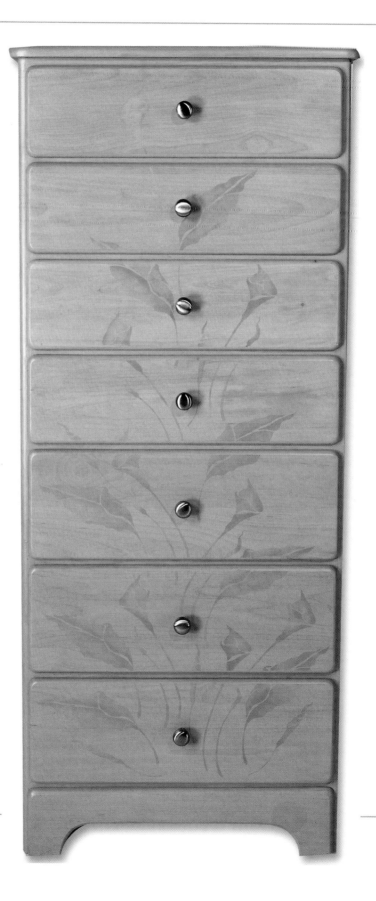

CALLA LILY LINGERIE CHEST

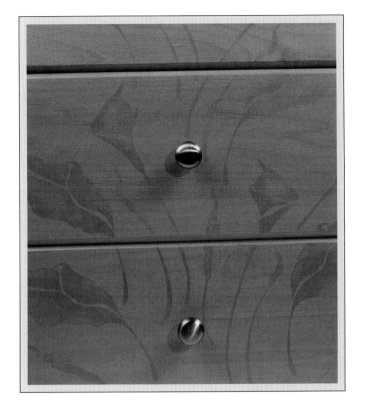

[ABOVE] Here you can see the three colors used to stencil the calla lilies and leaves. The first color applied to the calla lily stencil was a light silver. Next, copper highlights were added. Finally, a touch of gold was added. The same colors and sequence were used to stencil the leaves.

This tall lingerie chest is one of my favorite projects. The stylized calla lily stencil in soft metallic shades of silver, copper, and gold complements the character and color of the gray-stained pine. It appears as if the chest is emerging from an enormous bouquet of elegant calla lilies. Simple, copper drawer pulls add a final elegant note.

When stenciling a project such as this, tape the drawers together to stencil in a continuous pattern. That way you don't have to think about matching the pattern from one drawer to the next—just stencil as if on a flat surface. As seen in the detail photo above left, the stenciled calla lily design flows over the drawers in an unbroken pattern.

SOMETHING FISHY TUNIC

A sweatshirt pattern was used to create this pieced suede tunic. The center front strips were stenciled with a fish stencil, using a variety of metallic paints for a tropical look. As you can see from the detail photo of the back pocket, there's interest coming and going on this garment. When heat-setting paint on leather, be sure to use a hair dryer set at the highest temperature setting.

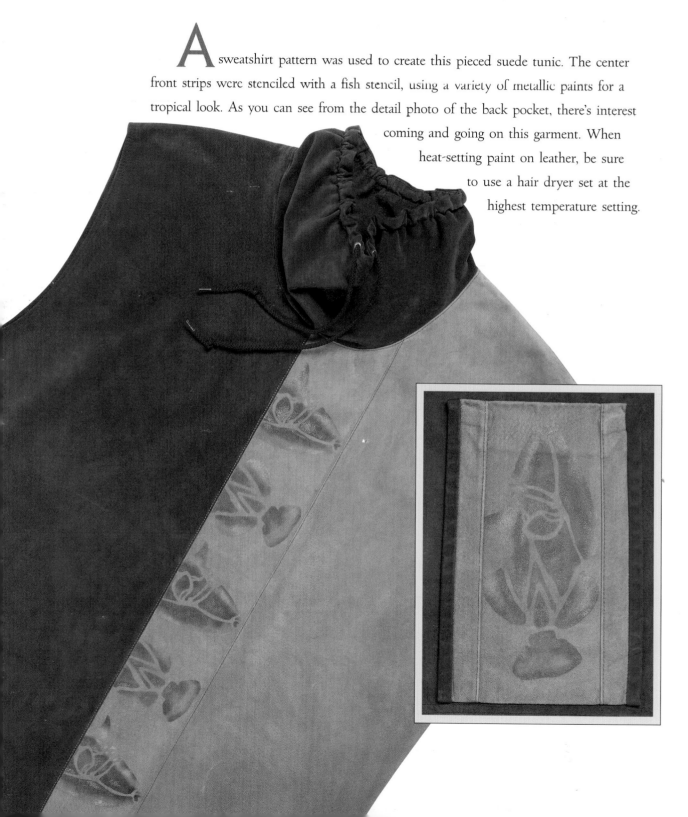

LEAF ENTRY HALL RUG

The stenciled leaf motif on the sisal rug was selected as a transition from the outside to the inside, and the sweeping arch of the motif helps soften the sleek contemporary lines of the room. I carried the leaf theme throughout the entry hall by using leaf motifs to emboss the suede chair seat and the leather tabletop, shown in the background and on pp. 130–131.

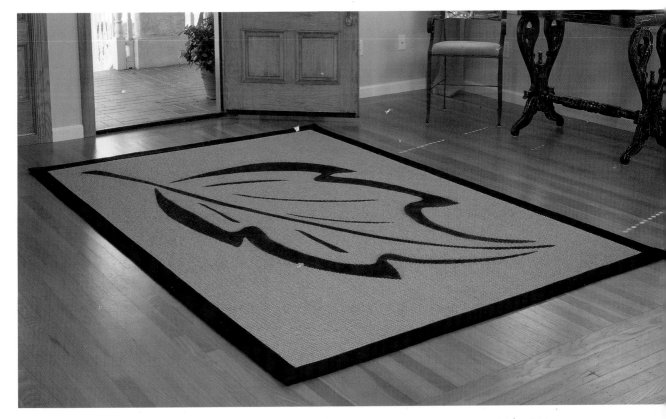

To make a stencil of this size, tape strips of freezer paper together to match the size of the rug. Draw the design and color it in if you'd like to check the image, then cut the stencil and attach it to the rug with temporary spray adhesive. For large projects such as this rug, it's best to use spray paint, which is easier and more practical for covering large areas. I used several coats of spray paint on this rug because sisal absorbs paint—lots of it.

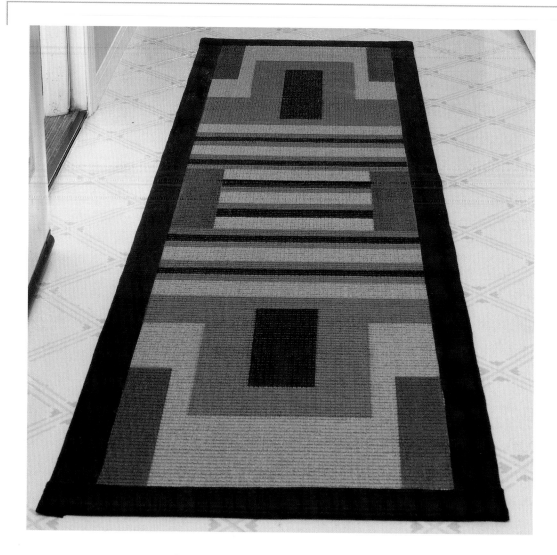

GRAPHIC FLOOR RUG

For this black cotton–bordered sisal rug, I wanted a more geometric look than the stylized leaf design of the entry hall rug shown on p. 69. So instead of making a stencil, I used varying widths of masking tape and nutmeg, taupe, and black spray paint to create the pattern. I started by masking off rectangles in the corners and center, then spraying with nutmeg brown paint. When using this method, remember to picture what an area will look like with the tape removed. Plan the placement of motifs and colors accordingly because you are working with both positive and negative space.

MARKET BASKET

Every Saturday I meet my friends at the local farmer's market to shop for produce for the week, and this basket is what I use to carry my purchases. The pocket on the side and the straps are made of olive split cow leather that was cut with a wavy-edged rotary cutter. The pocket and straps were then whipstitched onto the basket with narrow stay tape. I folded down the top of the pocket to create a flap and added a grasshopper in a deep green color to remind me of summer. Even the fine detail of this stencil shows up beautifully on the suede's rough finish.

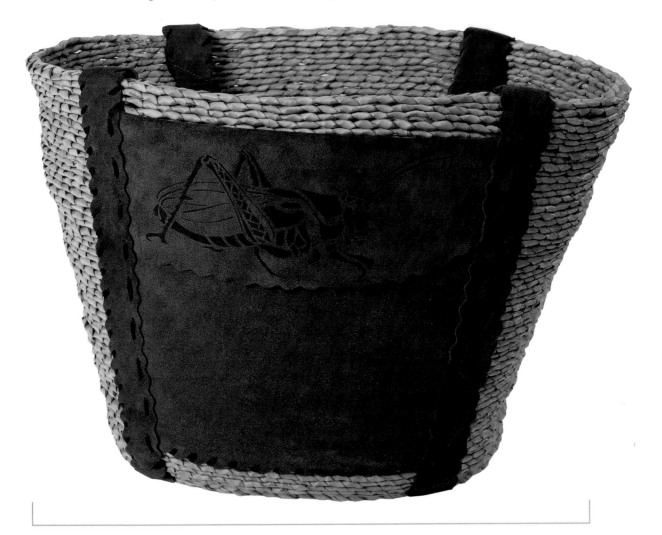

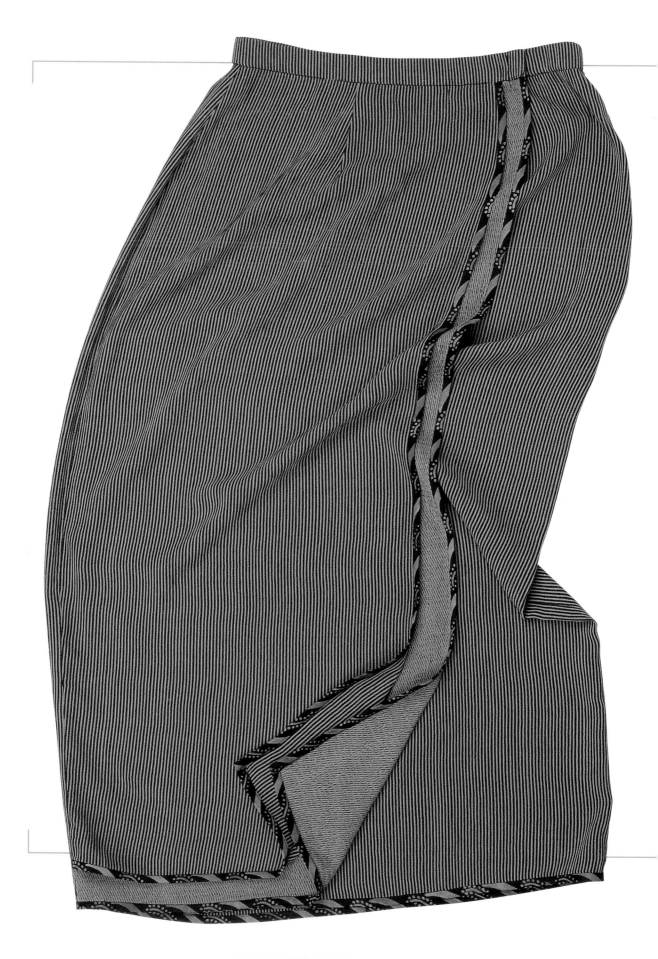

Ooo La Layers Wrap Skirt

Awrap skirt in black-and-cream rayon with an extra front panel is outlined in black silk bias that has been stenciled with cream paint. The bias edge is visually interesting, and the added weight of the trim helps the skirt hang smoothly, while still allowing soft movement. The faux finish of the border was achieved by blending two closely related colors. The black silk bias intensifies the slightly transparent quality of the paint and gives it a weathered appearance—a perfect complement to the fabric.

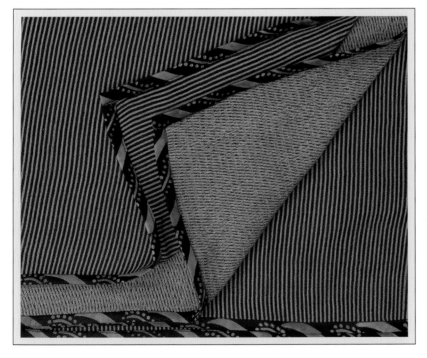

[ABOVE] I used a 1-inch-wide stencil on the trim and positioned the motif in the center of the 1¾-inch-wide silk bias strips. The silk bias comes precut in 5-yard lengths from Things Japanese (see Sources on p. 138).

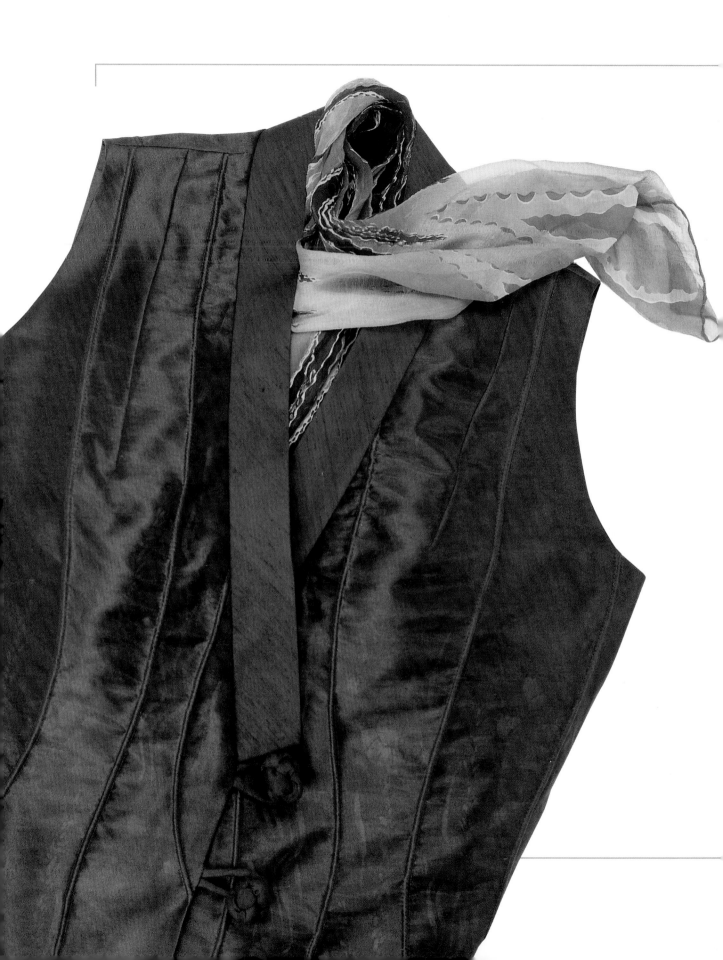

Sea Turtles Vest

An underwater scene of turtles swimming through sea grass is stenciled on aubergine silk dupioni, then covered with a layer of sheer aubergine organza. The suggestion of sea grass is further enhanced by sewing through both fabric layers with a wide, double needle in gentle curved lines, then filling the channels with soft aubergine chenille yarn.

[ABOVE] I tried three different metallic paint colors on this silk before deciding which looked most ethereal when covered with the organza layer.

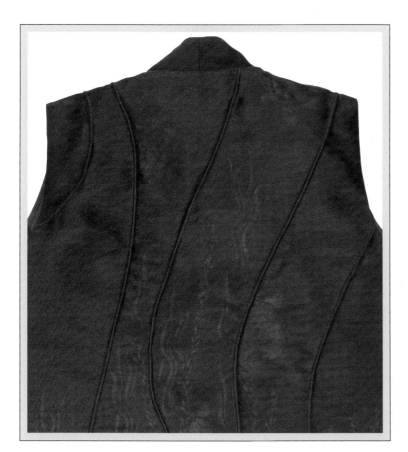

I used a 6.0mm double needle to create the channels for the soft aubergine chenille yarn; I then pulled the yarn through the channels using a crewel needle.

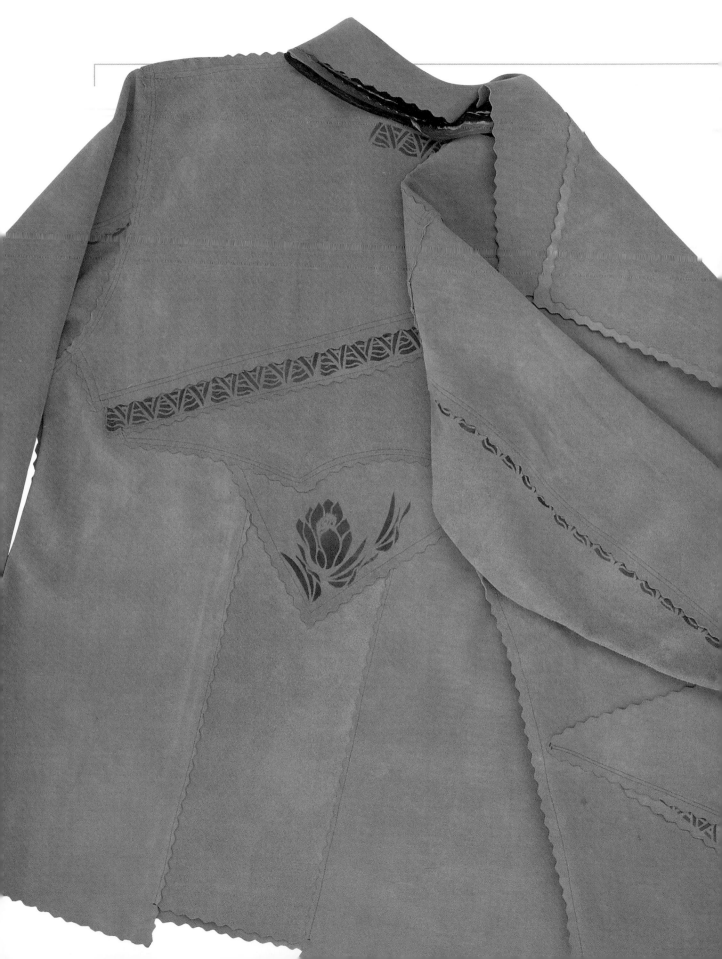

DESERT DELIGHT JACKET

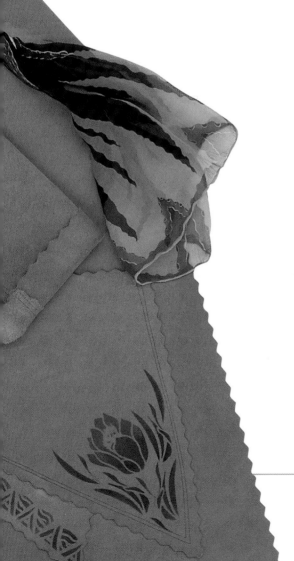

Stenciling intensifies the asymmetrical design lines of this split cow jacket. The jacket pieces are cut with a wavy-edged rotary cutter, and since leather does not ravel, the edges are left exposed to become part of the overall design. Stenciled borders accent the piecing lines on both the front and back of the garment. Construction and piecing seams are overlapped and topstitched, rather than sewn in the traditional manner. The desert flowersare highlighted with several shades of metallic paint, which adds dimension and texture to the floral motif.

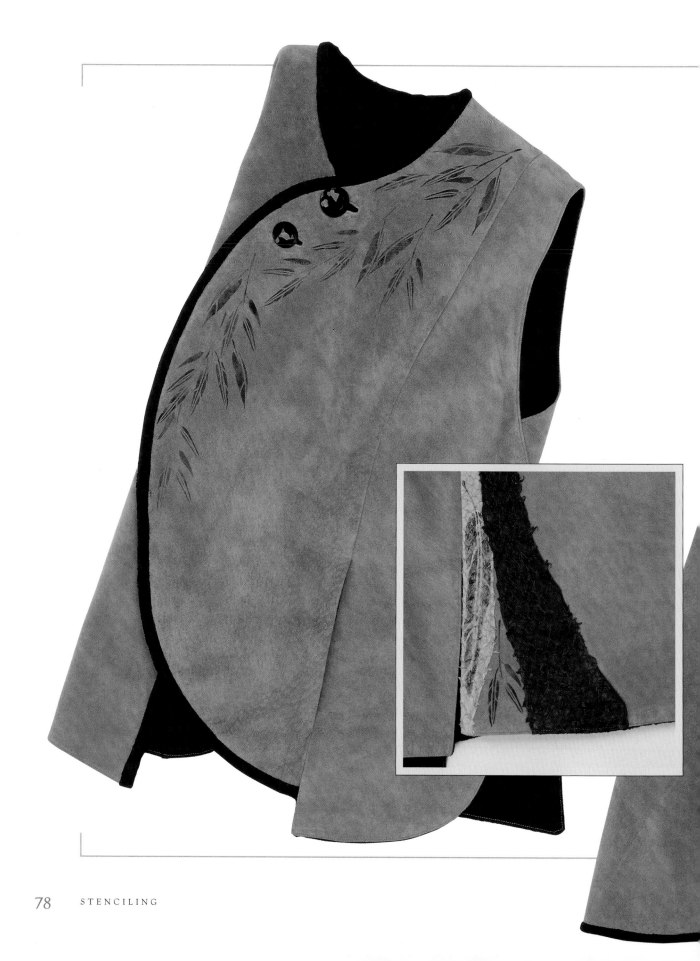

EUCALYPTUS ENSEMBLE

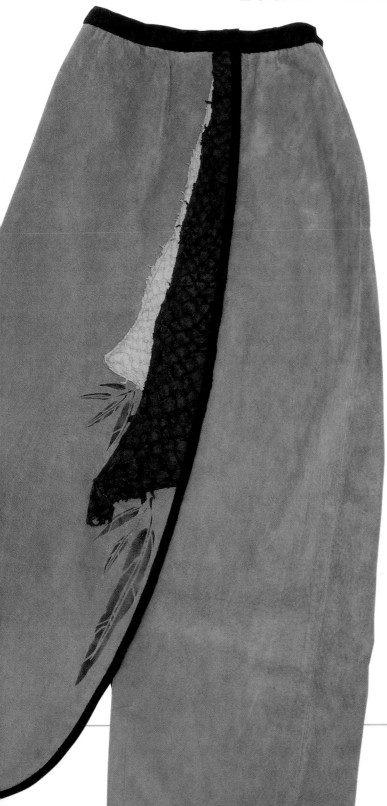

Eucalyptus leaves stenciled on soft sage suede and black-and-gray textured fish skins combine to create a serene feeling in this vest and skirt ensemble. (Fish skins are tanned like animal skins into leather with the added benefit of interesting texture patterns.) As you can see in the detail of the vest back, the textural qualities of the fish skins break up the stenciled image, softening it and keeping it in harmony with the rest of the design.

To extend a pattern, as I did on the left front of the vest, you'll need to clean and dry the stencil, then move the stencil or reverse it. Apply paint to the suede as described on pp. 51–54. Continue the stenciling process until the image is complete.

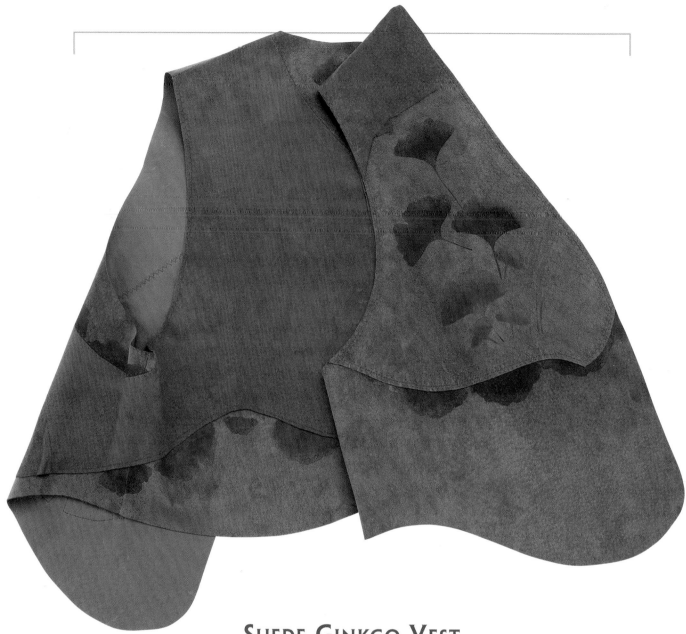

Suede Ginkgo Vest

gathered ginkgo leaves and copied them onto paper on a photocopier, then used the copies as templates to cut the several stencils used on this vest. (Refer to p. 50 to learn how to make stencils.) The plum fan-shaped leaves, accented with gold, pull together the unusual but effective combination of lavender and cognac suede. The leaf edges peeking out along the piecing lines were stenciled prior to assembly, which makes the images appear to be trapped between the layers.

Hot Salsa Skirt

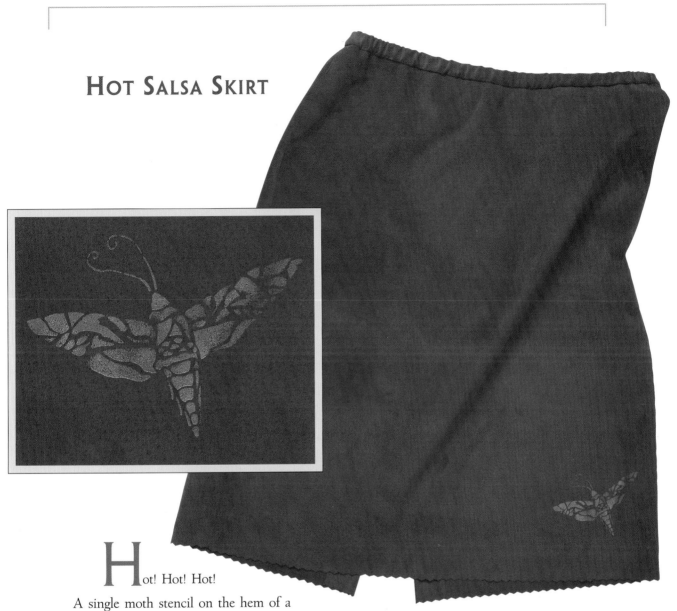

Hot! Hot! Hot!
A single moth stencil on the hem of a
watermelon suede skirt (part of a three-piece suit) takes it over the top. The single image
has more impact than would a multitude of moths covering the garment. Shiny metallic
green paint with bronze highlights was applied over metallic turquoise paint, adding more
complexity to the image than would a flat-finish paint. The metallic paint colors were
inspired by the colors of a striped camisole (not shown) and have nothing to do with real-
ity, but everything to do with fantasy. So little paint was applied that I was able to layer
one color after another without stopping.

CITRON AND RASPBERRY SUEDE VESTS

Using different stencils and color combinations will make the same vest look completely different. Here, citron suede is covered with every woman's fantasy—shoes! The stenciled motifs on the front and back of the vest have a dreamy quality due to the pastel highlights.

I made the same vest in darker colors and achieved a totally different look. The close-up photo shows the back of a raspberry suede vest that is stenciled with chocolate paint. The darker colors of raspberry and chocolate are more solid-looking, even though the stenciled image has a ribbon-like quality. The single stencil color on the raspberry vest appears more substantial than the highlighted pastels on the citron vest.

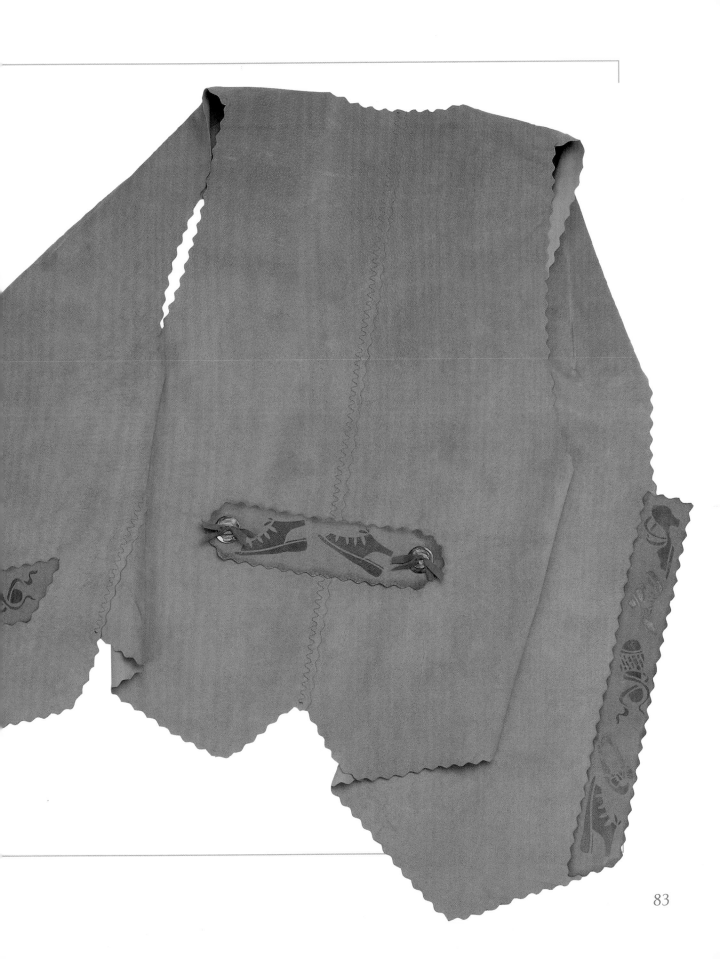

SILVER-STENCILED ASIAN JACKET

The organic shapes of the stencils on the lower front edges and center back of the linen under-jacket (shown in the close-up photo) are softened but not obscured by the window screen over-jacket bound in champagne silk dupioni. Antique silver paint on taupe linen gives the appearance of a wonderful pewter patina. Having fewer images to distract the eye makes those that are there more significant. This double jacket is part of an ensemble that includes a camisole and cropped pants.

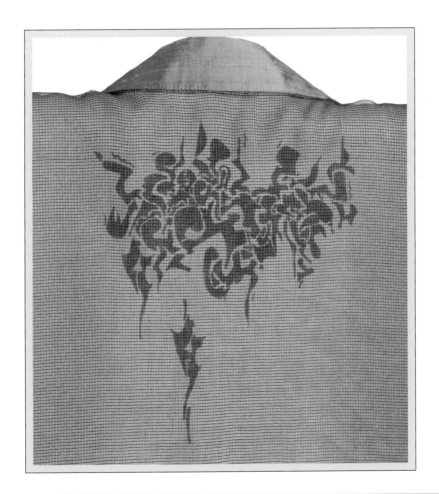

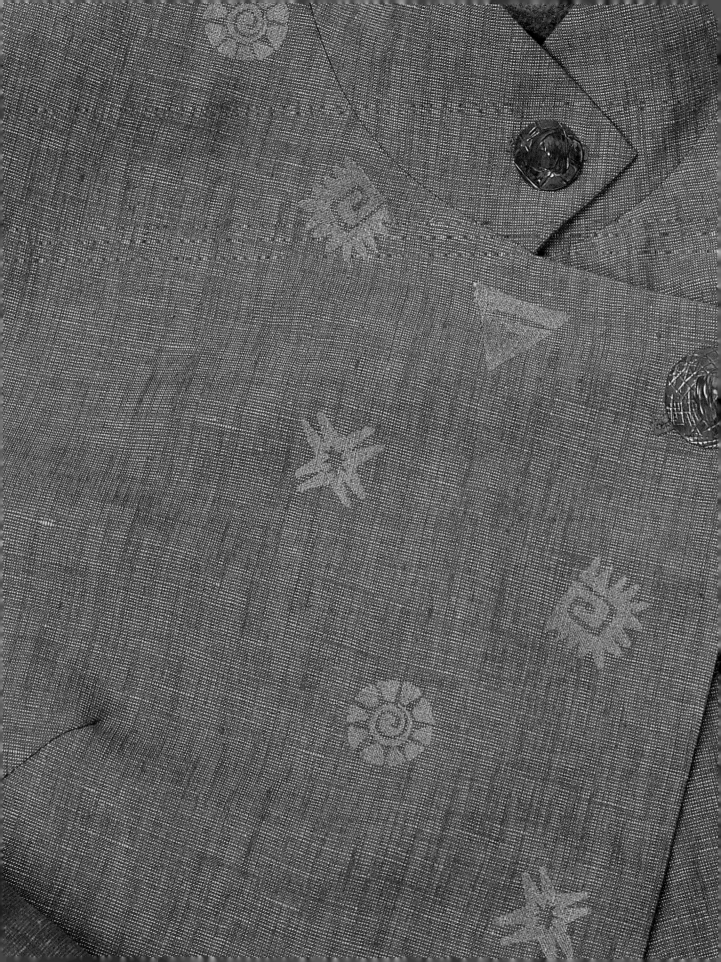

stamping

stamping

STAMPING IS A SIMPLE, STRAIGHTFORWARD TECHNIQUE: Paint is applied to a stamp, then the stamp is pressed onto a surface to transfer the image. The technique is easy to master, fun to do, and an inexpensive way to add immediate interest to both furniture and garments. Stamping leaves the lightest impression of the techniques covered in this book. However, its impact is anything but light, as you can see from the projects shown in the Stamping Gallery on pp. 100–119.

You can stamp with just about anything, from found objects to homemade stamps to commercial stamps. For those of us who are "drawing challenged," using commercial stamps will provide instant gratification. With the wide range of styles and types of stamps available, there is something to please everyone. Plus, the same stamp can be used in many ways; each use is unique to the artist and to the project.

In addition to providing basic stamping techniques, I've included information on how to make your own stamps, how to use variegated colors, and how to use metallic paint on velvet—a unique stamping variation that produces spectacular results.

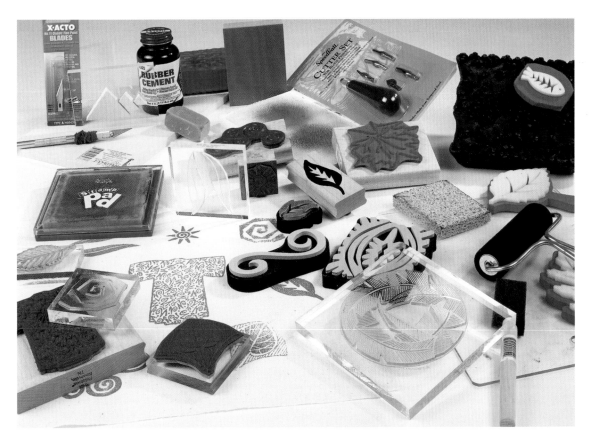

Use one of the many commercial stamps available or carve one of your own to transform a simple garment into a simply stunning one.

MATERIALS AND SUPPLIES

The supplies required for stamping are few. You'll need a stamp or other object to imprint the design onto a surface and a way of applying paint to the stamp. Beyond this, the specific tools you'll need will depend on your particular project and your preferences. If you would like to make your own stamp, see Making Your Own Stamp on pp. 92–93. for a list of additional supplies you may need.

Stamps

Stamping is a popular technique, and there are many companies that make wonderful stamps. One of my favorite commercial stamps is Pelle's See Thru Stamps™, which are made of a polymer material mounted on clear acrylic blocks. The clear acrylic makes it possible to see exactly where the image is positioned—a big advantage. My favorite supply sources for stamps are listed in the Sources listing on p. 138. If you want to make your own stamps, refer to Making Your Own Stamp on pp. 92–93.

Images stamped on coarse or loosely woven material (left) will not have the same crisp detail as images stamped on smooth, tightly woven material (right).

For most home decorating and clothing applications, it's best to use stamps with deeply cut images and limited detail, because small detail does not reproduce well on wood and fabric surfaces. The rougher the surface, the less detail that will register, as seen in the two samples in the photo above. The cotton sample on the right is more tightly woven than the linen sample on the left and produces a more crisp image.

Brayer (roller)

Stamping requires only a few tools. One of these is a 4-inch, dense sponge brayer (inking roller), which will evenly distribute paint on an inking plate. The brayer can also be used to apply paint directly to the stamp itself. If you buy this tool, be sure to purchase a sponge brayer because hard rubber brayers do not work as well for this technique.

Inking plate

Clear acrylic inking plates are versatile tools that can be used as paint palettes or to check image placement. To learn how to use an inking plate for design placement, see Stamping Idea File on p. 99.

Stamp pad

Stamp pads (also called inking pads) are washable foam pads set in a plastic container. Paint is spread evenly on the foam, then the stamp is pressed into it. This method provides even coverage and produces a good, clear image.

Sponges

Sponges have a variety of uses. Compressed sponges and high-density sponges can be used to create stamps. Small 1-inch sponge brushes can be used to dab paint directly onto the stamp.

STAMPING TECHNIQUES

Read through the information below to learn basic decorative stamping techniques and to discover intriguing variations that are fun to try. Perfect your technique by practicing on paper or fabric scraps. Then, when you're ready to tackle a project, just select some paint, grab a stamp, and get started.

Preparation

Whether you're stamping on fabric or on wood, you'll need to prepare the surface as you would for any painting project (see chapter 2, pp. 27–29).

If stamping on fabric, pad the prepared fabric with paper or muslin to absorb excess paint and prevent bleed-through onto other surfaces. Secure the fabric to an easel or a work surface with pins or staples to prevent the fabric from moving and smearing the image.

For knits such as cotton T-shirts, iron the shiny side of freezer paper to the back of the

I used this block print–style stamp to decorate airy chiffon curtains with regularly spaced motifs. The black permanent mark in the center of the image helps align the image with placement marks on the fabric.

fabric using a synthetic fabric setting on the iron. Leave the freezer paper in place until the stamped image has been heat-set.

If you want to space a motif at regular intervals, as I did to make the curtains shown on p. 107, mark the fabric before you begin to eliminate guesswork. For placement, I marked the center of the stamp with a permanent marker, then used a tape measure and a temporary marker to mark the center position of each image on the fabric.

Making Your Own Stamp

Making your own stamps can be as simple as carving a design into a halved potato. However, although a carved potato serves as an effective stamp, it has a very short shelf life. If you plan to use a design more than once, use a linoleum or Speedy Cut™ block, either of which can be carved to produce complex designs. To carve the image, use a Speedball® cutter set, which consists of a handle with several interchangeable blades.

LINOLEUM CARVING BLOCK

Linoleum carving blocks come premounted in a variety of sizes and can be found at art supply stores. The blocks are most often carved to make stamps, but they can also be left uncut.

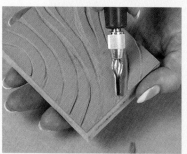

1. To create a carved stamp, draw the image directly on the linoleum block surface with a pencil or marking pen. Use a Speedball cutter to gouge out the areas not included in the design. Always direct the blade away from your body and hands for safety.

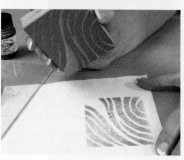

▲ Once the design is completed, make a test stamp to be sure the cuts are deep enough and that all excess material has been removed.

2. The linoleum carving block can also be left uncut to create interesting patterns.

▲ Apply paint to the uncut linoleum block with a brayer, then remove some of the paint with a rubber-tipped tool to create a pattern.

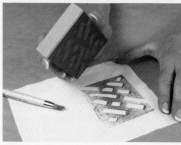

▲ When you're satisfied with the pattern, use the block to stamp the surface, using firm, even pressure.

SPEEDY CUT CARVING BLOCK

A Speedy Cut carving block, which comes in a variety of sizes, consists of a very dense, spongy material that is mounted, after the image is cut, onto a support block.

1. Cut the block to a size appropriate for your design. Draw the image directly on the block, then cut the image from the block using a Speedball cutter or a craft knife.

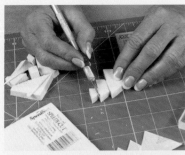

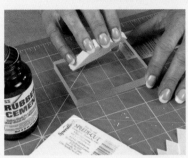

2. Use rubber cement to mount the Speedy Cut stamp to a clear acrylic or wood block that is slightly larger than the stamp.

3. Once the stamp has been cut and mounted, it's ready to use.

UNIQUE STAMP MATERIALS

Everyday household items make unique, inexpensive stamps. Just reach into the fridge or a kitchen drawer and pull out...an apple or an eraser, a bell pepper or a piece of string. The possibilities are endless.

▲ Vegetables and fruits can make terrific stamps. Choose firm pieces, such as apples and green peppers, and cut them in half through the stem to get a full image. Perishable items such as these will last about a week if refrigerated in a plastic bag.

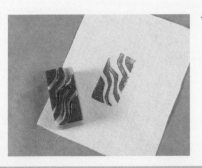

▲ An art gum eraser carved with a sharp craft knife, is another great stamp idea.

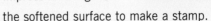

▲ High-density sponges, available from craft-stores, also make interesting stamps. Heat the surface of the sponge with a heat gun, then impress an image into the softened surface to make a stamp.

▲ Regular sponges can be used as is to create an interesting textured stamp, or you can cut them into shapes with sharp scissors. If you plan to cut the sponge, purchase compressed sponges. It's easier to draw the image and cut it out while the sponge is still compressed; then dip the sponge in water to expand it to its normal size.

▲ For an alternative way to make stamps, mount double-sided tape on heavy cardboard, foam core, acrylic blocks, or wood blocks and attach items to create patterns.

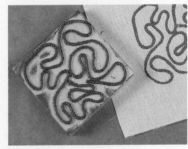

You can use anything that will adhere to the tape and remain level for printing. If the surface isn't level, the stamp won't print properly. Here, tape has been applied to the surface of a 4-inch acrylic block. String is then arranged on the tape in a random pattern. Be sure to use tightly twisted string and avoid crossing it over itself to keep the surface level. Spray with varnish to seal the stamp and to cover exposed areas of tape.

Applying paint to a stamp

Here are three easy ways to apply paint to a stamp. Try each method and see which one works best for you.

1. Use a brayer/roller to spread the paint in a thin, even layer on an inking plate (top photo below). Then press the stamp into the paint on the inking plate (bottom photo below).

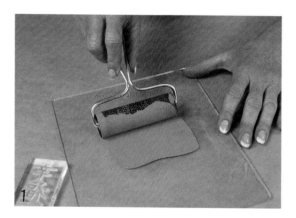

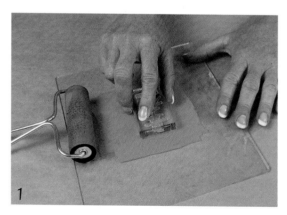

2. Use a brayer to roll a thin layer of paint directly onto the stamp.

3. Use a stamp (or inking) pad: Pour a small amount of paint onto a blank pad (top photo below). Work the paint into the inking pad with a craft stick or the back of a plastic spoon (bottom photo below). When the paint is well distributed on the pad, press the stamp onto the pad, using a firm tapping motion.

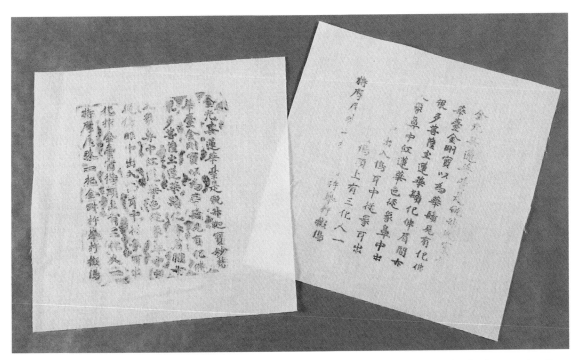

To create clean, complete images, apply a thin, even layer of paint to your stamp and transfer the image using firm, even pressure. The samples above show the result of using too much paint (left) and uneven pressure (right).

Applying paint to the surface

Stamping requires more paint than stenciling does, but using too much paint will blur the image. Before stamping your project, experiment first on paper or a scrap of fabric to find the right amount of paint to use.

In the photo above, the image on the left shows what happens when too much paint is applied to the stamp. The incomplete image on the right shows the result of using uneven pressure when stamping. Practice your technique until you get an image you like.

1. After paint has been applied to the stamp, press the stamp onto the surface of your proj-

ect, using firm, even pressure. Do not rock the stamp because this can blur the image. Repeat stamping as needed to complete the design.

2. If the paint is drying too quickly, add water or extender to increase the open time.

$3.$ Keep the stamp clean as you work. Dried paint is difficult to remove and will blur the image. Baby wipes are handy for this cleanup task; just be sure to blot the stamp dry on paper towels before reapplying more paint.

3

Special effects

After you have mastered the basic stamping techniques, try these variations to add greater dimension to your work.

VARIEGATED COLORS This stamping technique uses two or more paint colors at one time to produce interesting effects. The added depth and tone of variegated colors creates a richer image, which is much more appealing than a flat-looking single-colored image, as you can see on the suede sample below. Paint "reads" differently on different surfaces, so be sure to test the paint colors before starting your project.

[RIGHT] Blend two or more different colors of paint at one time to give stamped images an almost three-dimensional look.

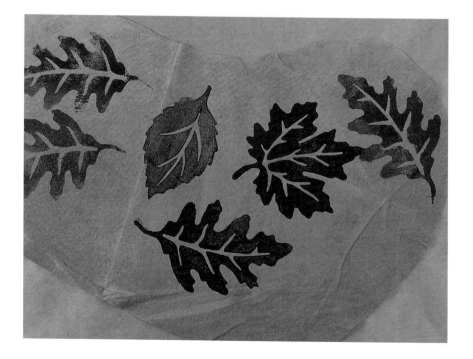

1. To achieve this look, drop small amounts of different colored paints next to each other on the palette or inking plate.

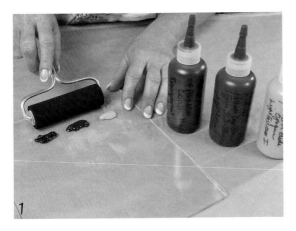

2. Roll the brayer through all the colors to blend them together at the edges.

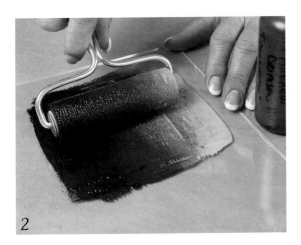

3. Dip the stamp into the blended paint.

Handy Tips

▲ If you don't have a brayer to roll paint onto a stamp, use a foam paintbrush or a small sponge instead. These both make good paint applicators, plus they're easy to use and inexpensive.

▲ If you're interrupted while working or you need to stop for a few minutes, lay damp paper towels over the palette and slip it into a plastic bag. This will preserve the wet paint for a few hours, sometimes longer. But once the paint is dry, it can't be restored, and you'll have to start over with a clean palette.

▲ For masking effects, Mask-It™ (available from Purrfection Artistic Wearables; see Sources, p. 138) can be used again and again.

▲ To keep track of your stamps, tape a piece of paper to each of your storage boxes, then stamp an image of each stamp stored in that box. This will save time when you are looking for a particular stamp. A quick glance at the label tells all.

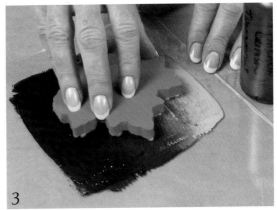

4. Press the stamp onto the project surface, using firm, even pressure.

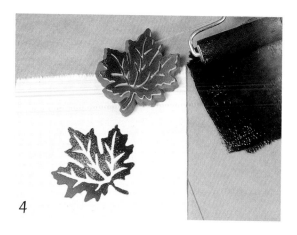

4

METALLIC PAINTS ON VELVET Textile artist Marcy Tilton has developed a technique for stamping metallic paints on velvet. It takes practice, but produces beautiful results.

1. Choose a stamp with a bold design and deeply carved lines. You may want to make your own stamp to ensure lines are cut deeply enough.

2. Dab a generous amount of paint onto the stamp, using a sponge brush.

3. Practice stamping on scraps to see how much paint and pressure is required for the fabric. Too much pressure will flatten the pile and blur the image. Nap lays in one direction, so work with the nap as you stamp.

Finishing

When you have finished stamping, clean the stamp with a soft brush and soap and water or with a stamp scrubber. Then let it dry on paper towels. You can also use rubbing alcohol for cleaning; this is a good solvent that won't damage stamps.

Allow the finished project to dry thoroughly, then heat-set or varnish, as required. See chapter 2, pp. 34–35, for how to finish designs on fabrics and wood. Store clean stamps on their sides rather than stacking them. This will protect the stamping surface, as well as make the stamps easier to see. I store mine in shallow plastic boxes with lids. A piece of paper with an image of each stamp taped to the side or top of the box is a big time-saver.

Stamping Idea File

Once you've mastered the basics of stamping, it's fun to experiment with different effects. Clockwise, starting from the top photo:

▲ For variety, apply paint to only part of the stamp or restamp the image in a different color to create a shadow effect.

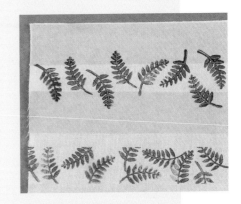

▲ Create a simple border by using masking tape to mask off an area, as I did in this sample, and stamping within the masked area.

▲ Create a shaped area or a block-print effect like those used on screen-printed T-shirts.

▲ Check what a motif will look like before putting it on the actual surface: Stamp the image onto a transparent plastic inking plate, then hold the inking plate over the exact spot you plan to stamp on. This way, you can see immediately how the image is going to look on the project before it's permanently applied. Fiber artist Dana Bontrager came up with this clever idea.

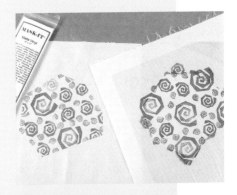

▲ Preview a pattern of images by first stamping the images on paper. Then cut them out and arrange them on the surface of your project. When the pattern pleases you, mark the position of each image with a tiny pencil mark that will be covered by the stamp. *(For the completed project, see p. 118.)*

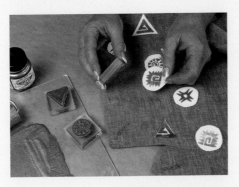

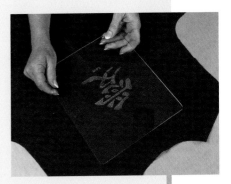

SOUTHWEST-MOTIF PILLOWS

Stamped images of a dancing man and woman and Kokopele (the humped-back flute player of Native American lore) are scattered across these pillows made of suede and heavy cotton. The two larger pillows also feature a stencil that is an enlarged version of the diamond pattern found on a handwoven pillow that served as the inspiration for this group of pillows.

The pieced and stenciled pillows [BELOW] feature geckos made with commercial stencils. I created the Kokopele stencil by using the stamp from the small, stamped pillow [BOTTOM, ON THE FACING PAGE]. To do this, I stamped an image on paper and enlarged it on a copy machine, then I used the image as the pattern to cut the stencil. Highlighting the images on the pillows gives them interest and depth.

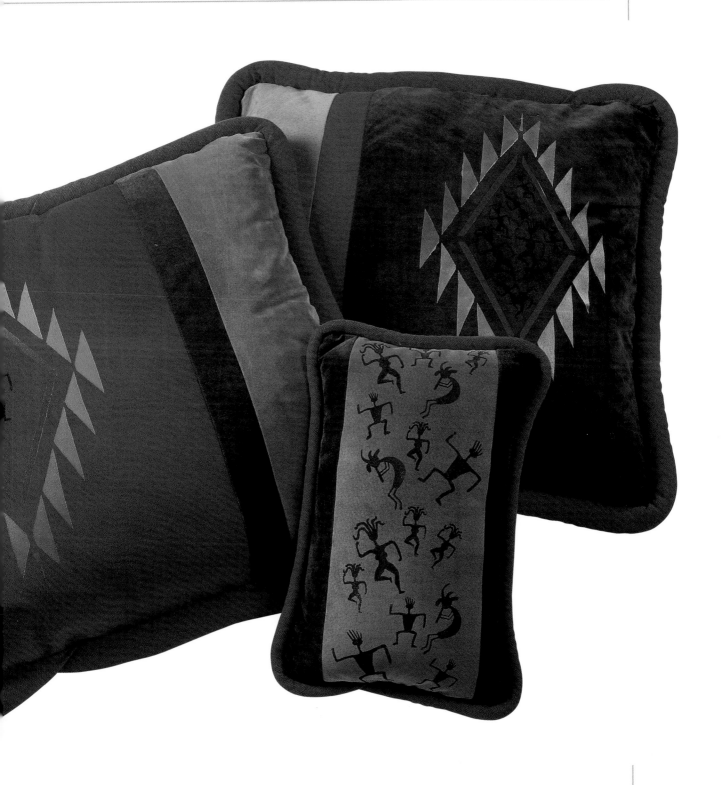

DOG AND CAT VESTS

Denim is always a good choice for children's garments. In the dog bone vest, both the outer denim layer and the lining of checked cotton are stamped with images. Choosing a single color for the stamping—in this case, black—unifies the design. The bound edges of the vest make it reversible, adding an element of fun for the child to enjoy. These stamps came in a sheet and had to be separated before I used them.

The kitty-motif girl's vest is also denim lined with cotton. Choosing paint colors for stamping on denim can be tricky because it tends to "eat" color. I tried several paints before finding one that was vibrant enough to stand out on denim. Bound edges make this garment reversible, as well.

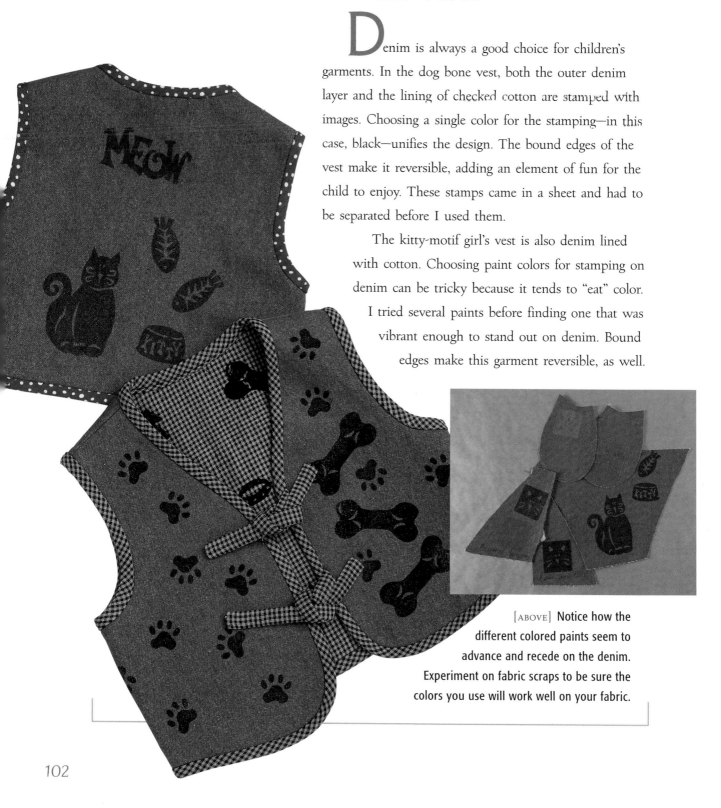

[ABOVE] Notice how the different colored paints seem to advance and recede on the denim. Experiment on fabric scraps to be sure the colors you use will work well on your fabric.

102

VARIEGATED LEAVES TABLE

Tabletops are a wonderful surface to embellish. This slightly odd-shaped table with barn-wood legs rests between two burgundy leather recliners in a TV room. The scattered stamped images lend a casual feel to the room, and the sueded leather is an inviting contrast to the slick leather finish of the chairs. The images of fall leaves were created by stamping with variegated colors, which adds depth and dimension to an image. When working on a large piece of suede such as this, I tape it to the work surface to keep it from shifting.

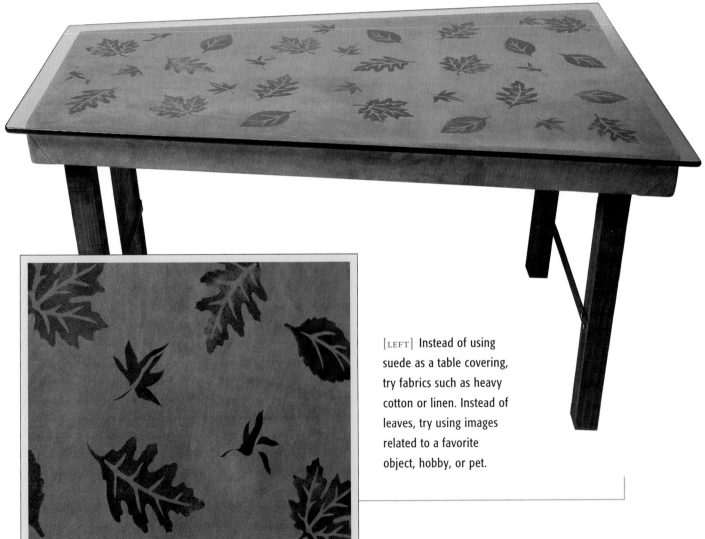

[LEFT] Instead of using suede as a table covering, try fabrics such as heavy cotton or linen. Instead of leaves, try using images related to a favorite object, hobby, or pet.

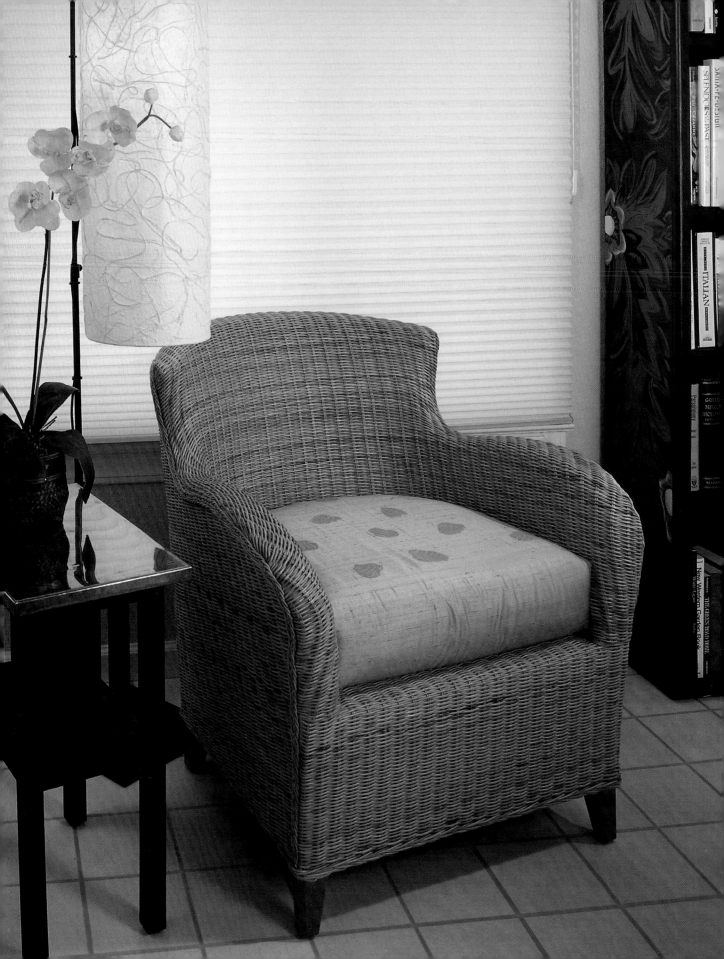

LEAF CUSHIONS

Tone-on-tone stamping on the silk dupioni wicker chair cushion is a perfect complement to the painted bookcase and copper-topped table in this sunroom. The original ivory linen on the cushion was far too bland for the room's theme, and bright hues would have competed with the décor in adjacent rooms—but this pale citron fabric works beautifully. The paint selected for the stamped images is a custom blend made to just barely contrast with the fabric. Imagine how different the cushion would have looked if the paint were a bright tropical green: The contrast would have overwhelmed the other elements in the room and been distracting to the eye.

[LEFT] It takes a bit of experimentation to get just the right color paint for a tone-on-tone look such as this because the paint can "disappear" or take on undesirable undertones. If mixing a custom color, be sure to mix enough to finish the project because it's very difficult to re-create the exact same color blend.

DRAGONFLY BEDROOM

The feel of this bedroom is luminous and gossamer, like the transparent wings of a dragonfly. The simplicity of this Asian-style bedroom is enhanced by the stamped dragonfly patterns on the curtains and the chair pad. The curtains on each window are circles of polyester chiffon that have been hung over a bamboo rod. A close-up, at right, reveals the subtle metallic dragonfly, created with a block print–style stamp, that decorates the fabric. When light pours through the curtains, the images appear to float on air.

[LEFT] Orchid and pale sage silk dupioni frame the single dragonfly image that is stamped in metallic purple on the rocking chair cushion. The positive and negative aspects of the stamp are well displayed in this treatment. Though tightly woven, the fabric's texture is rather rough, so the image is slightly broken, giving it an aged look. The bright periwinkle border gives the cushion the appearance of a framed picture.

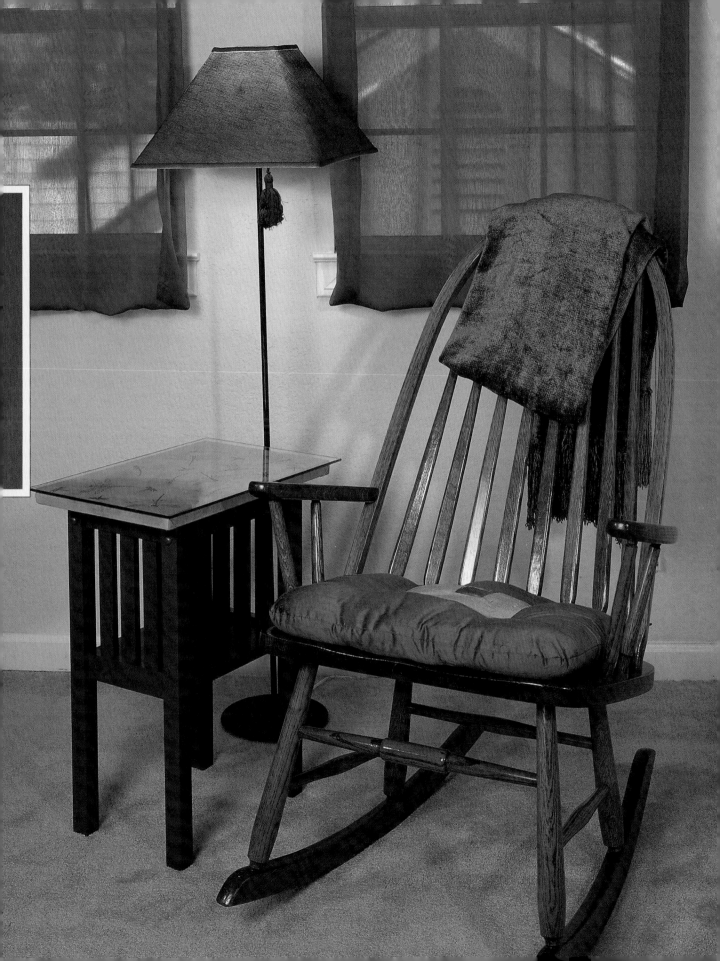

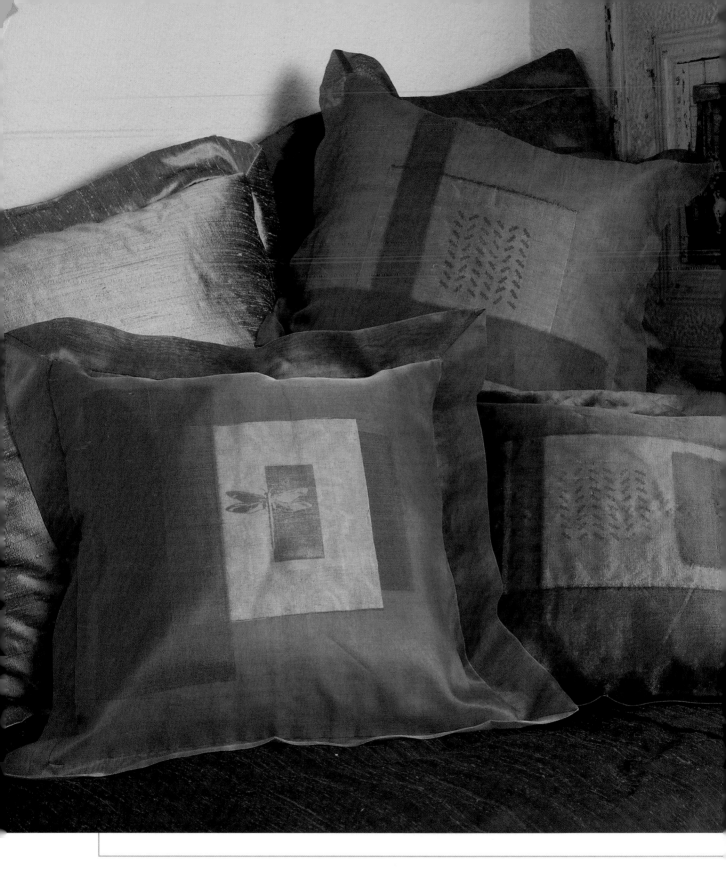

Gossamer Organza Pillows

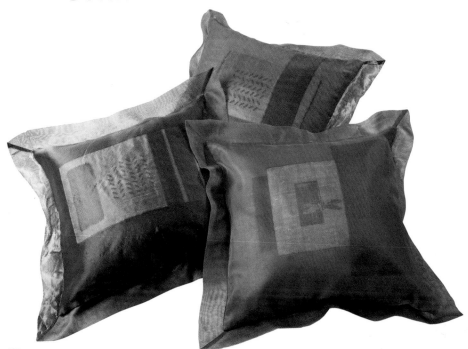

Variations of the dragonfly motif, in shimmering shades of metallic paint, are used throughout the room shown on p. 107. The transparent quality of the organza was the inspiration for the entire room. The wonderful palette of copper, periwinkle, mulberry, and sage provided lots of choices for the complementary color scheme.

The stamped images are soft and ethereal-looking due to the covering of organza, yet each is strong enough to stand on its own. The images were stamped on pale sage silk dupioni, then inserted between double layers of organza. Strips of aubergine organza were inserted between the layers to add design interest. Even though several different colors were used on each pillow, the colors all have similar value, which creates harmony.

Fusible webbing is the magic ingredient that secures the layers of fabrics on these pillows. Once applied, it becomes virtually invisible and prevents the fabrics from shifting as the pillow is used.

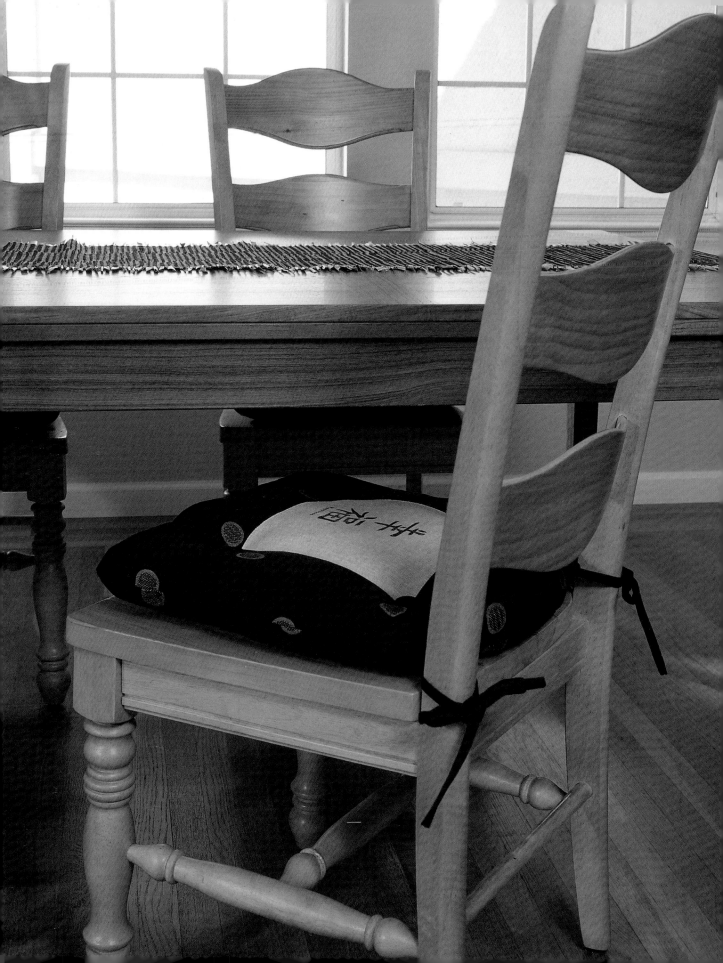

ASIAN CHAIR PADS

Just a hint of the stamped images on the chair pads peeks out from under my dining room table, lending a sense of drama to this space. The black symbols stand out in sharp relief against a background of natural linen, which is appliquéd to upholstery fabric featuring a pattern reminiscent of Chinese coins. The whole scene welcomes guests, from the tranquil black-and-natural color scheme to the Chinese characters that extend warm wishes for happiness, prosperity, serenity, and peace.

In the photo below you can see how the coarse linen breaks up the stamped image to give it a weathered, venerable look. Mercifully, the stamp provides an English translation for those of us who don't read Chinese.

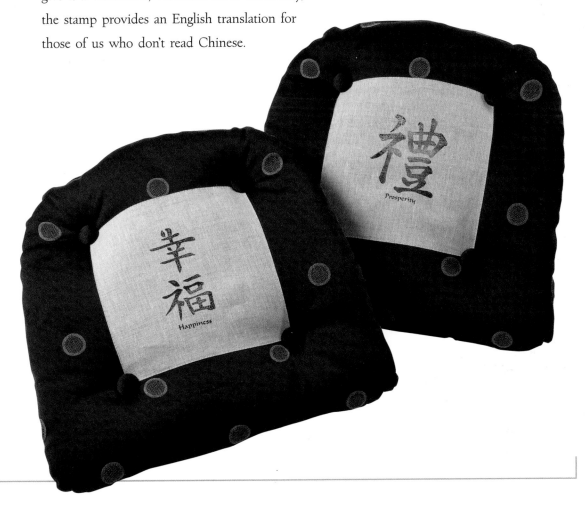

NOVELTY LINEN DUSTER

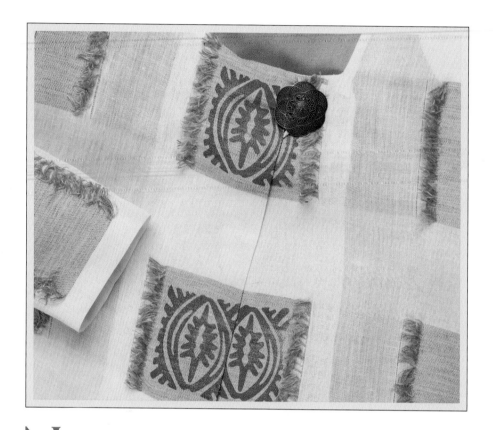

Never pass up the opportunity to use unusual materials in your designs, such as the novelty linen I used to make this duster. When using unusual fabrics of this type, try using bias trim instead of the usual facings for a more professional look. The large metal button at the top is supported by several snaps to keep the look crisp. I wear the duster with a solid top and pants to take full advantage of the fabric's character.

The ethnic-looking stamp just fills the natural-colored squares. The deeper shade of the antique gold paint pops against the lighter background color, proving that a mono-chromatic theme is anything but boring. When stamping, always work on a flat, hard surface covered with paper to protect the fabric.

CHILD'S BEANBAG CHAIR

The primary color scheme and the stamped paint splotches and lug-soled footprints on this half-sized beanbag chair are playful elements that appeal to a child's sense of whimsy. The beanbag chair is made of denim and is about 30 inches in diameter. Although denim is strong, I reinforced the seams with piping. The Styrofoam® beads that fill the chair are contained in a muslin liner cut from the bag pattern. Zippers in the seams of both the bag and the liner make for easy access for refilling as needed. I tacked the lining and the bag zipper tabs closed with a few hand stitches.

Although it's a good choice for children's items, denim fabric can make most paint colors "disappear." To avoid this, use paints that are bright and opaque. They'll stand out better on denim—and kids love 'em.

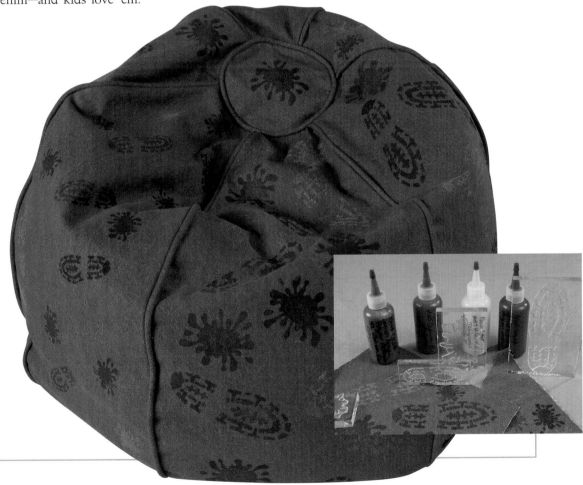

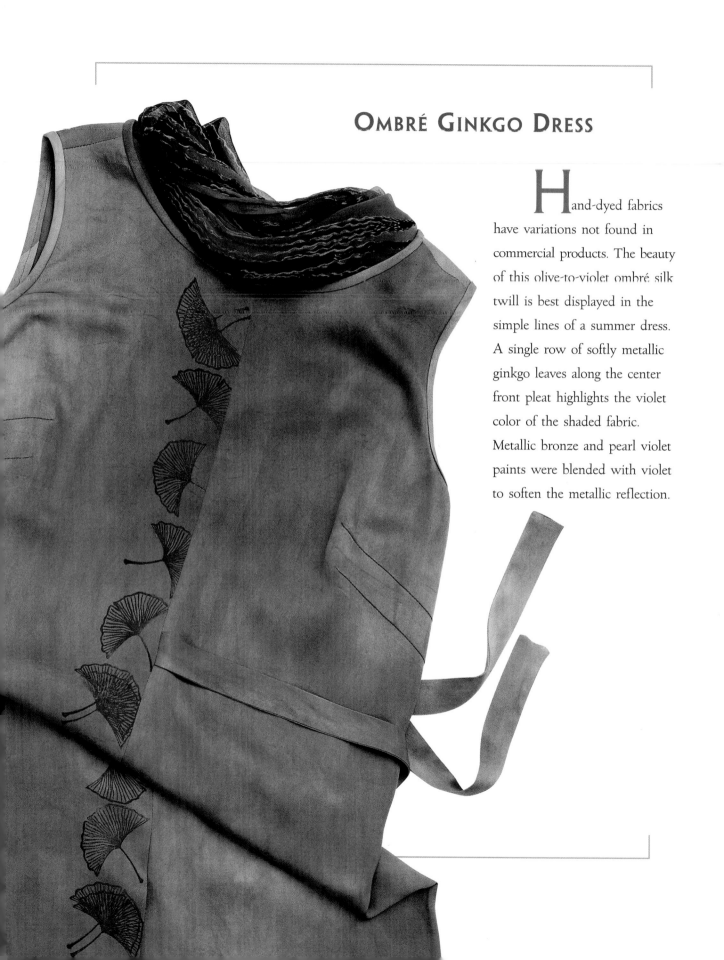

OMBRÉ GINKGO DRESS

Hand-dyed fabrics have variations not found in commercial products. The beauty of this olive-to-violet ombré silk twill is best displayed in the simple lines of a summer dress. A single row of softly metallic ginkgo leaves along the center front pleat highlights the violet color of the shaded fabric. Metallic bronze and pearl violet paints were blended with violet to soften the metallic reflection.

Miyaki-Style Aprons

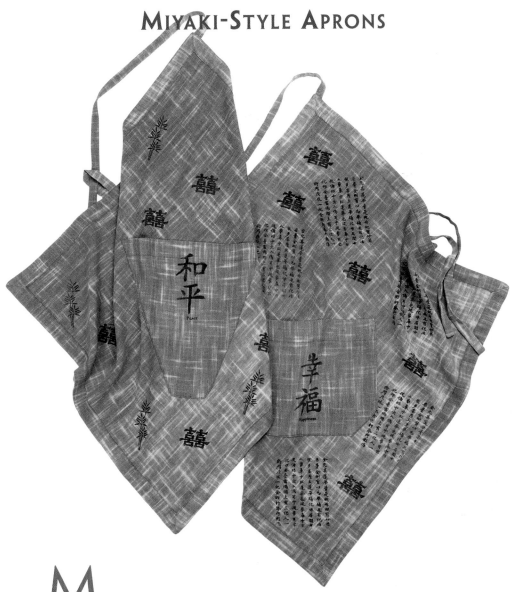

My favorite apron is the Miyaki bias style, which is simply a rectangle of cloth supported from a corner to shift it to the bias (diagonal to the grain of the fabric). These aprons are basically blank canvases awaiting artistic inspiration. You can make the rectangles whatever size you want and use whatever finish techniques and embellishments you prefer. These stamped versions reflect the Asian characters of Miyaki (above). To learn how to create the color blends seen in the fall leaves, see pp. 96–98.

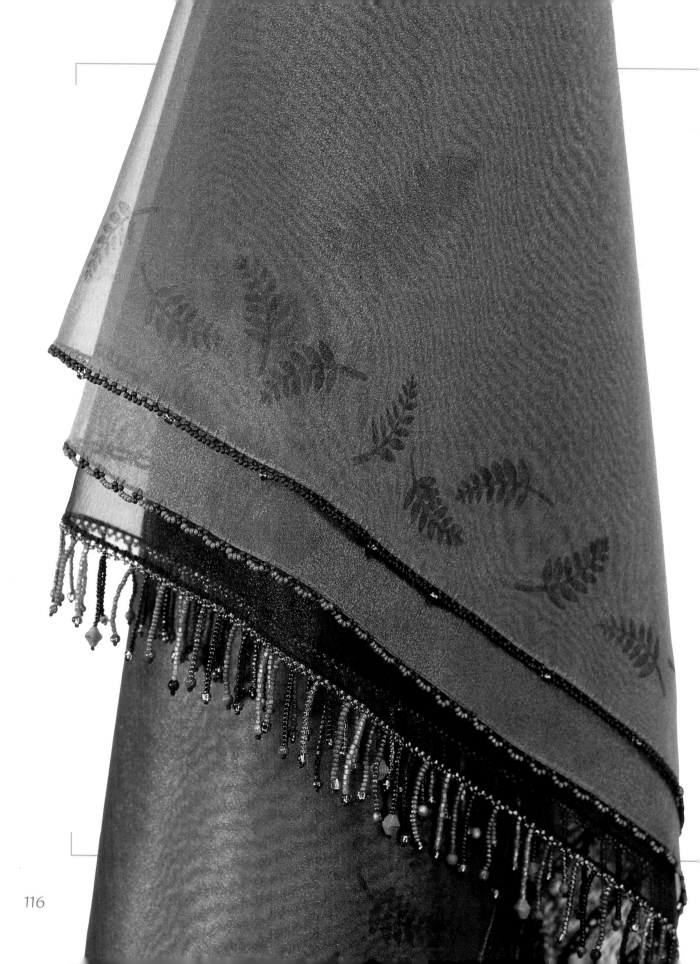

LAYERED ORGANZA SHAWL

This is my favorite project in the whole book. I'm fascinated by transparency, and the idea of seeing different images as light passes through this glamorous evening shawl intrigues me. I experimented with different paint colors and intensities until I achieved the look seen here. The almost analogous color scheme of aubergine, periwinkle, and mauve is revealed by the slight difference in size of each layer. Attached only at the top, the three layers float separately, adding a sense of movement to the scattered fern leaves stamped on the middle periwinkle layer and the tiny fronds bordering the top mauve layer. Lavish beading and the tassels on the corners elevate the wrap to showstopper status.

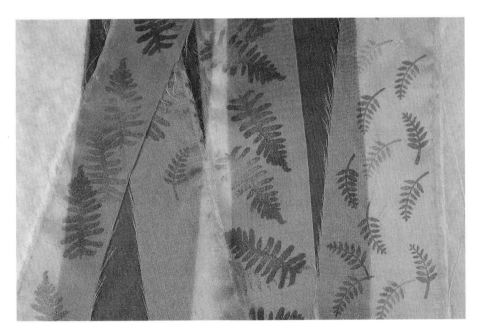

[ABOVE] Experiment with different paint colors and intensities to achieve the look you're after, as I did here.

SAMURAI SHIRT

Cross-dyed linen fabric is the backdrop for this Asian-inspired shirt jacket. The asymmetrical design lines are accented with small, metallic bronze stamped images and hand-made buttons. The colored fibers in the cross-dyed fabric soften the appearance of the metallic paint, giving it a rich glow.

Before stamping directly on this shirt, I first stamped the images on paper. I then cut them out and placed them on the fabric, adjusting their positions, until I was satisfied with the arrangement. Only then did I replace each image with the actual stamp. Just a few images sprinkled along the edge are enough to create interest without overkill. Less is often more than enough when it comes to embellishment.

SHAWL COLLAR BATHROBE

This fabric's small geometric triangle pattern in ice-cream colors has just enough of a twist to appeal to me. Repeating the triangle motif in a variety of stamps and choosing paint colors from the fabric keeps the design consistent while adding enough interest to satisfy. Some of the stamps are commercial, and some were hand-carved from a Speedy-Cut carving block. Refer to pp. 92–93 for instructions on how to do this.

[BELOW] Test paint samples on your fabric before starting any project because the color may not "read" quite as you expect. After experimenting with different options, I added opaque white to achieve tints similar to those in the fabric. Remember: Always test first.

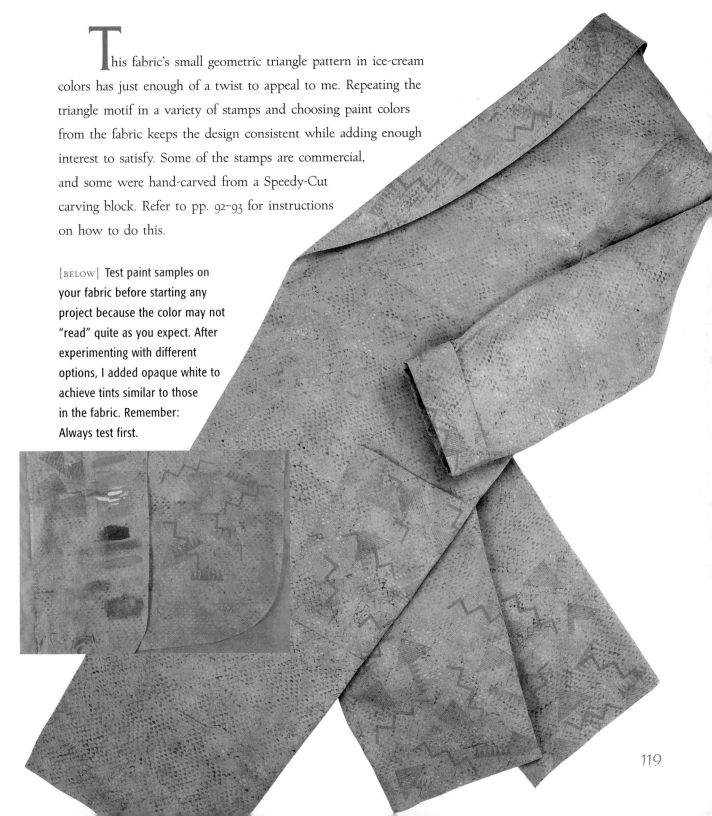

embossing

embossing

EMBOSSING IS A VARIATION OF STAMPING; this technique uses a stamp or other embossing agent to *impress* an image rather than transfer paint to a surface. To be effective, the surface to be embossed must have some depth because the image is crushed into the surface using heat, pressure, and, sometimes, moisture. As with stamping, you can use a variety of everyday items to impress the image, as long as they are heat-resistant. Since tiny detail is lost with this technique, be sure to choose bold, deeply cut images.

My favorite embossing surfaces are velvet, leather, and suede. The method gives a rich, luxurious character to these sumptuous materials, as you can see from the projects shown in the Embossing Gallery on pp. 130–137. As you read through this chapter, you'll learn which fabrics are best to use and those it's best to avoid. In addition to learning how to obtain successful results with the basic embossing techniques, you'll discover a special variation—embossing with metallic paint—that yields stunning results. So let those creative juices start flowing, allow your imagination to soar, and try your hand at this intriguing technique.

Use deeply carved embossing agents that have simple, well-defined details to emboss an image onto a surface.

MATERIALS AND SUPPLIES

Since embossing is a variation of stamping, it's not surprising that the technique uses many of the same materials as stamping (see chapter 4, p. 89). Read through the specific techniques that follow for any special supplies you may need.

Embossing agents

An embossing agent is the item used to impress the image into the surface. The pri-mary tool for embossing is a deeply cut stamp, preferably one with a simple image, which will yield the best results. But many other items can also be used as embossing agents. See the Handy Tips on p. 129 for fun suggestions. Just be sure the item you select is thick enough to create an impression and sturdy enough that it won't be damaged by the crushing process.

Pressing cloth

A Teflon® pressing sheet is a valuable aid in preventing heat damage to the fabric being embossed.

Paint

Paint can be used as part of the embossing process by applying it to the embossing agent prior to making the impression. My preference is metallic-finish paint because I like the rich look it lends to evening wear. See Embossing with Metallic Paint on the facing page for details on this technique. If some other paint finish appeals to you, by all means try it on a sample. After all, the whole point is to create something that appeals to you.

Other supplies

You'll also need an iron and a fine-mist spray bottle for embossing any fabric except leather and suede.

EMBOSSING TECHNIQUES

Plan your design placement before you start working. Avoid placing designs over construction seams or on top of the bust point. Since you will be working from the wrong side of the fabric, you can easily mark where each image will go. If design orientation (up, down, left, right) is important, be sure to mark that as

Embossing is effective on a variety of fabrics, such as the cross-dyed velvet (left) and the slinky knit (right).

well. It's well worth the few extra minutes this step takes.

Types of fabrics to use

Embossing is permanent when applied to leather, suede, and acetate/rayon velvet. Silk/rayon velvet will yield beautiful, subtle results, but the effects may not be permanent. On other fabrics, the results are often disappointing: Polyester fleece fabrics will lose the embossing once the fabric is washed, and, personally, I don't think it's worth the effort for only temporary results. Fabrics containing nylon or nylon blends may melt from the heat of the iron, and cotton velveteen doesn't give good results. My advice is to stick with leather, suede, and the acetate/rayon or silk/rayon velvets. I especially like the cross-dyed velvets

Embossing with Metallic Paint

A unique variation of the embossing technique is leaf embossing with metallic paint. This technique was developed by fiber artist Marcy Tilton, and it produces an elegant effect. Here, I'm using silver metallic paint to emboss a pale blue silk sweater. The leaf patterns are somewhat irregular, and they crush the pile. The overall effect on a garment is stunning, as you can see in the photo on p. 133.

As with all painting techniques, practice on scraps of fabric before starting your project. When there is no extra fabric to test on, practice your technique on the inside of the garment. Select a spot under the arm or near a side seam, as shown in the top photo. That way, if the process doesn't work, you can still wear the garment.

1. Select a substantial leaf with a prominent vein pattern on the underside. Begin by dabbing a fairly generous amount of paint onto the back of the leaf using a sponge brush.

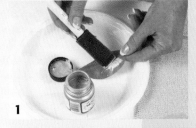

2. Lay the sweater right side up on an ironing board. Place the leaf, painted side down, on the sweater.

3. Heat a dry iron to medium-high temperature. Place a Teflon-coated pressing cloth over the leaf, then press with the iron for 20 to 30 seconds.

4. Carefully remove the leaf, beginning at the stem end. Repeat these steps until the pattern is complete, using a new leaf for each impression. Then, stand back and admire your work. You can touch up missed spots with a small paintbrush.

Artist's Insight For leaf embossing with metallic paint, use sturdy, leathery leaves, such as the camellia leaves I used on my sweater.

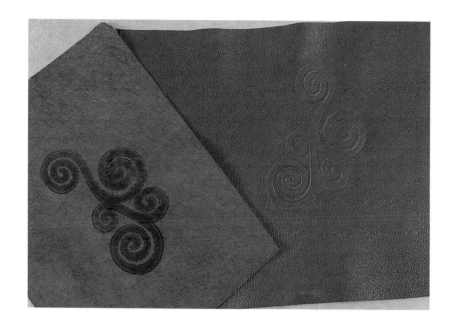

[RIGHT] I've had good results embossing on sueded leather (pig suede, left) and smooth leathers (lamb napa, right), but try a sample of the leather or suede you plan to use.

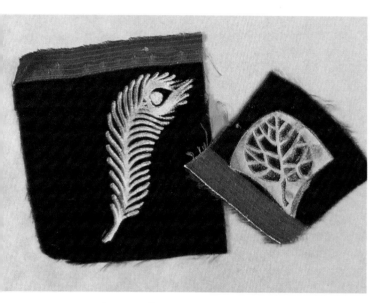

[ABOVE] These cross-dyed velvet samples show the crisp, clear image produced by a deeply carved stamp (left) and a less well-defined image from a more shallow stamp (right).

(where the pile is a different color from the warp), which look incredible when embossed. As you can see in the photo on p. 124, when this cross-dyed velvet sample is embossed, the underlying pewter color shows through. The sample on the right is a slinky knit, which also embosses well.

Embossing leather and suede is like branding, but the heat is applied from the underside. If the leather is too thick, the heat may not be able to penetrate well enough to make the impression. Some sueded leathers don't register an impression well, so always test a sample before proceeding. I've had good results with garment and upholstery cowhide, pig suede, and smooth lamb napa. In the photo above, the sample on the left is pig suede, and the sample on the right with the smooth finish is lamb napa.

Embossing velvet

When embossing, remember that the longer you press with the iron, the stronger the impression will be. When selecting stamps for embossing, choose deeply carved stamps that will produce a simple, clear image, as demonstrated by the sample on the left in the bottom photo on the facing page. Images that are too shallow or too complex tend to blur, as demonstrated by the sample on the right.

1. Lightly spray the back of the velvet with water from a fine-mist spray bottle. Place the stamp (or whatever embossing agent you're using to make the image) faceup on an ironing board. Lay the velvet facedown over the stamp.

2. Place a pressing cloth or Teflon pressing sheet over the velvet. Preheat the iron to a medium-high temperature; do not use the steam setting. Press for 20 to 30 seconds,

depending on how strong you want the impression to be. Lift and move the iron around slightly to minimize the effect of the iron's steam holes. Lift the iron and repeat as necessary to complete the pattern.

Embossing leather and suede

To emboss leather and suede, repeat the technique used for velvet, but eliminate the light water spray. Since leather contains about 10% to 12% residual moisture, condensation may form on the stamp as you press with the iron. If condensation touches the leather, it will make permanent stains, so you need to keep checking the stamp for moisture and blotting it with paper towels.

Leather and suede can shrink or stretch slightly when embossed, so take care when placing images. The embossing results can be unpredictable, so always practice on a scrap

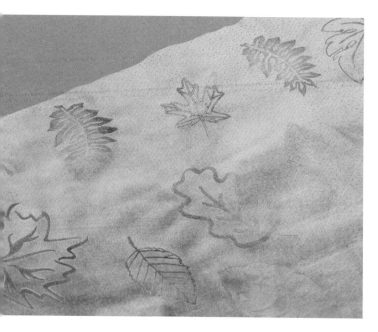

2

3

piece first. Before making the seat for the chair on p. 130, I experimented on a scrap of suede with a variety of leaf shapes and placement options, then I selected the most pleasing effect.

1. Lay the leather facedown over the stamp. Cover with a Teflon-coated pressing cloth, and press for 20 to 30 seconds.

1

2. Remove the pressing cloth and fold back the leather to check for moisture on the embossing stamp and to see if more pressing time is needed.

3. Keep checking for condensation as you press with the iron. Use a paper towel to absorb all moisture on the stamp surface to ensure that the leather doesn't become stained.

Embossing with cording

Although stamps head the list of embossing agents, an image can be created with a variety

of other items. One embossing agent I like to use is cording, which can be arranged in a multitude of patterns on the pressing surface. This is a great way to make a border on velvet.

1. Lay cording on the ironing board in the desired pattern, making sure the cording does not cross over itself, which will make the embossed pattern uneven. Lay the velvet face-down over the string and lightly mist the fabric with water.

2. Next, lay a Teflon-coated pressing cloth over the velvet. Heat the iron to a medium-high temperature, then press for 20 to 30 seconds.

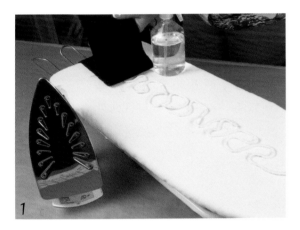

Handy Tips

▲ Some cookie cutters work well as embossing tools, but avoid using plastic or nylon cutters, which will melt. The cutting edge on metal cookie cutters may be too sharp to use, but if you turn them over, the rolled edge will usually work fine. Cookie-cutter motifs can be especially charming on children's wear.

▲ Heavy cotton lace is another terrific embossing agent, as long as it is thick enough to leave a distinct pattern. Lace impressions look great on collars and cuffs or even as a border on cropped pants.

3. Then, fold back the velvet to check the embossed pattern.

Finishing

Once the embossing is completed, it's permanent, with the exceptions previously mentioned in the text. For cleanup and storage of stamps, see chapter 4, p. 98.

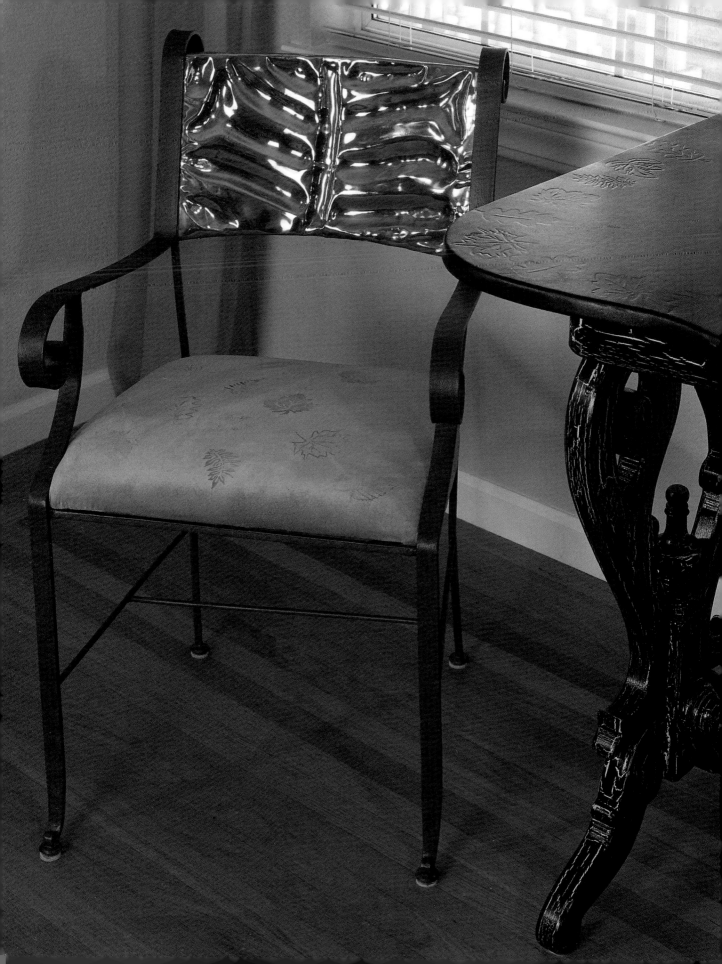

EMBOSSED LEATHER TABLE AND SUEDE CHAIR

Curving lines on the armchair and table soften the contemporary theme of this entry. The natural materials of suede and leather are in a pleasing neutral palette of black, taupe, beige, and cream. The embossed leaf images on the chair seat and on the black cowhide tabletop echo the natural motifs of other elements in the room.

The spectacular copper-backed side chair is made even more impressive with the addition of a suede-covered seat, embossed with a variety of commercial stamps. Metallic surfaces such as the copper and aged iron of this chair are reflective and hard, so the tactile taupe pig suede is a good complement. The close-up view of the chair seat at right reveals the wispy, light feel of the embossed leaf images, which are scattered lightly across the seat.

[OPPOSITE] Leather and suede can shrink or stretch slightly when embossed, so plan the placement of motifs carefully, especially when outlining the edges of furniture, as on the table shown here. Be sure to allow enough extra material to pull to the underside for stapling.

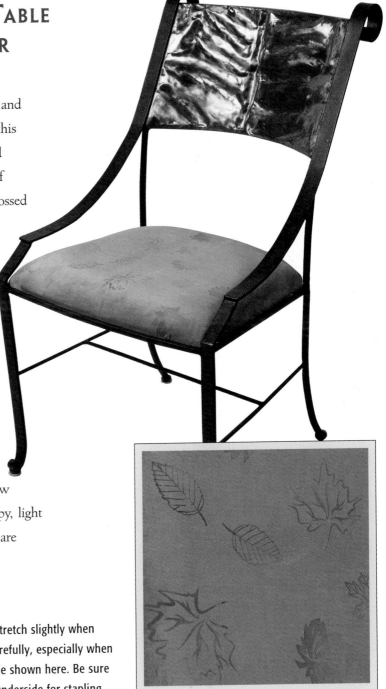

BLACK VELVET EVENING BAG

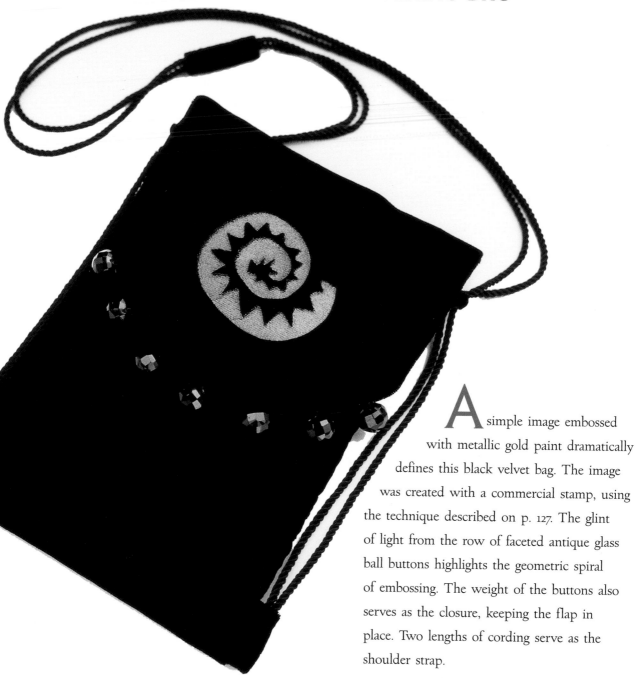

A simple image embossed with metallic gold paint dramatically defines this black velvet bag. The image was created with a commercial stamp, using the technique described on p. 127. The glint of light from the row of faceted antique glass ball buttons highlights the geometric spiral of embossing. The weight of the buttons also serves as the closure, keeping the flap in place. Two lengths of cording serve as the shoulder strap.

SOFT WRAPPED SWEATER

Subtle silver leaf embossing enhances the pale milk-thistle blue of this silk sweater. I used sturdy camellia leaves for this project because they are tough enough to withstand the heat of an iron. The undersides of the leaves were painted, then the leaves were embossed on the sweater, one by one. To learn more about embossing with metallic paint, see p. 125.

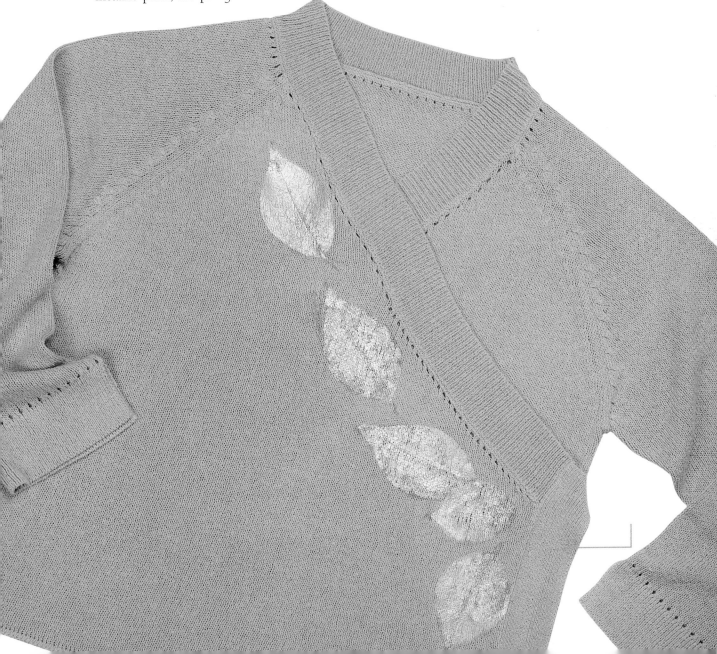

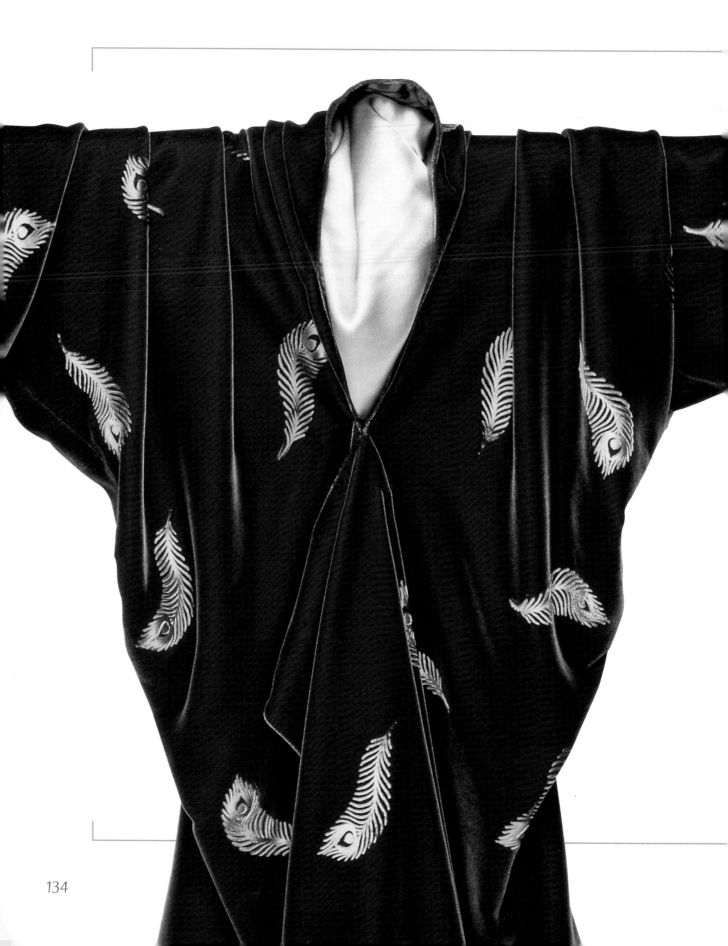

MIYAKI-INSPIRED JACKET

The beauty of the peacock feather embossed on this cross-dyed burgundy velvet fabric speaks for itself. The underlying silver color of the fabric is obscured until embossing crushes the pile. The simple lines of this Miyaki-inspired jacket provide the perfect backdrop for the images, making any further embellishment unnecessary. The feathers are placed and oriented randomly on the fabric, but are relatively evenly spaced from each other.

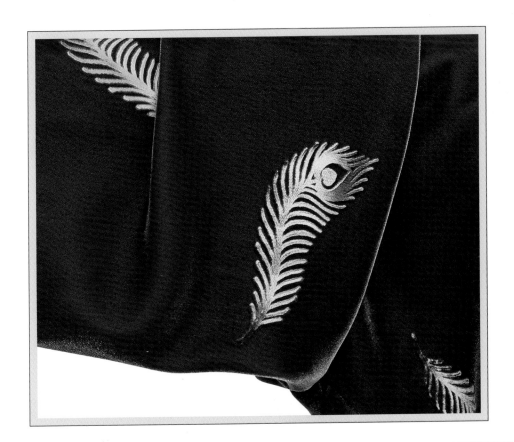

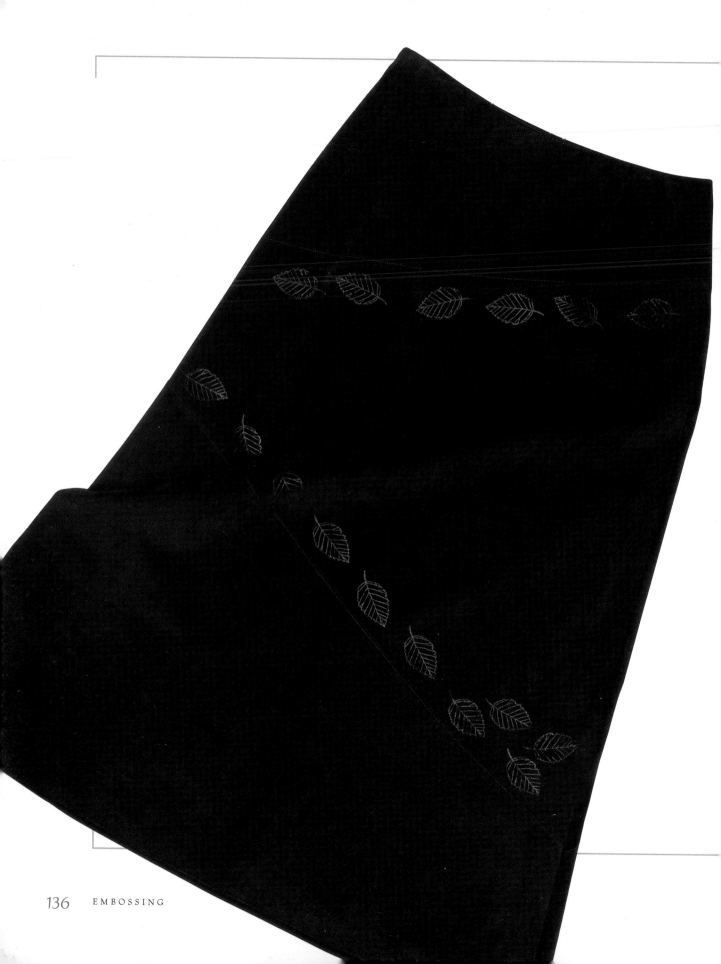

Falling Leaves Skirt

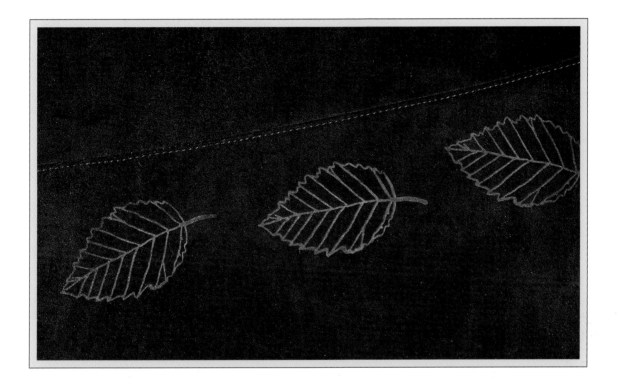

Opposing diagonal piecing lines served as the placement guides for the embossed birch leaves on this black suede skirt. When the skirt is worn and light catches the leaves, the diagonal placement and random orientation of the images make it look as if the leaves are falling. This, in turn, gives the garment a very fluid feel.

Be sure to make samples with the stamp and materials you plan to use. I found that the outline stamp (shown in the detail photo) embossed a much more attractive image than did the solid stamp on this particular suede.

sources

Cheap Joe's Art Stuff
374 Industrial Park Dr.
Boone, NC 28607
(800) 227-2788
www.cheapjoes.com
Art supplies

Counterpoint
371 South Main Street #40
Sebastopol, CA 95472
(707) 829-3529
Buttons, clasps, closures

Dick Blick Art Materials
P. O. Box 1267
Galesburg, IL 61402-1267
(800) 828-4548
www.dickblick.com
Art supplies

Dover Publications, Inc.
31 East 2nd St.
Mineola, NY 11501-3852
(516) 294-7000
www.doverpublications.com
Catalogs of copyright-free images

Dressler Stencil Company
253 SW 41st St.
Renton, WA 98055-4930
(888) 656-4515
www.dresslerstencils.com
Stencils, stenciling accessories

Hot Potatoes
2805 Columbine Place
Nashville, TN 37204
(615) 269-8002
www.hotpotatoes.com
Rubber stamps, stamping accessories

Jacquard Products
Rupert, Gibbon & Spider, Inc.
P. O. Box 425
Healdsburg, CA 95448
(800) 442-0455
www.jacquardproducts.com
Lumiere and Neopaque paint, related products

**Nova Color Artists'
Acrylic Paint**
Artex Manufacturing Company
5894 Blackwelder St.
Culver City, CA 90232-7304
(310) 204-6900
www.novacolorpaint.com
Paint

Purrfection Artistic Wearables
12323 99th Ave.
Arlington, WA 98223-8852
(800) 691-4293
www.purrfection.com
Patterns, stamps, stamping supplies, paints, stencils, buttons, fabric, notions

ReVisions/Diane Ericson
305 Beach St.
Watsonville, CA 95076
(831) 768-8652
www.revisions-ericson.com
Patterns (ReVisions Designs and Design & Sew), stencils, creative coaching

The Rubber Poet
P. O. Box 218
Rockville, UT 84763-0218
(435) 772-3441
www.rubberpoet.com
Stamps

SF Designs
2641 Evening Sky Dr.
Henderson, NV 89052
(702) 650-2345
samsew@earthlink.net
Patterns

Things Japanese
9805 N.E. 116th St., PMB 7160
Kirkland, WA 98034-2287
(425) 821-2287
www.silkthings.com
Silk fibers, silk-related products

Utrecht Art Supply
6 Corporate Dr.
Cranbury, NJ 08512
(800) 223-9132
www.utrecht.com
Art supplies

index